IMAGES
of America

STURGEON BAY

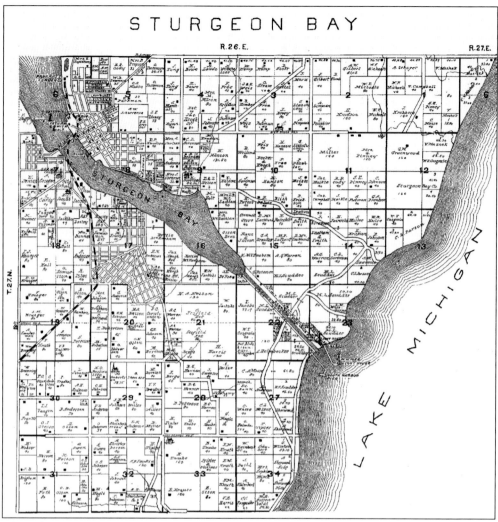

The *Atlas of Door County Wisconsin* from 1899 shows the plat map of the township and city of Sturgeon Bay.

IMAGES
of America

STURGEON BAY

Ann Jinkins and Maggie Weir
for the Door County Historical Museum

ARCADIA

Published by Arcadia Publishing
Charleston SC, Chicago IL, Portsmouth NH, San Francisco CA

Printed in the United States of America

Library of Congress Catalog Card Number: 2005937810

For all general information contact Arcadia Publishing at:
Telephone 843-853-2070
Fax 843-853-0044
E-mail sales@arcadiapublishing.com
For customer service and orders:
Toll-Free 1-888-313-2665

Visit us on the internet at http://www.arcadiapublishing.com

CONTENTS

Acknowledgments 6

Introduction 7

1. Beginnings 9

2. Crossing the Water 21

3. Downtown – East Side, West Side 31

4. Public Service 57

5. Family Life and Recreation 71

6. Tourism Beginnings 95

7. Working Waterfront 105

8. Orchards 117

ACKNOWLEDGMENTS

We thank the Door County Board of Supervisors for supporting us in this project. In particular, we are grateful for the approval of the museum committee consisting of chairman Dan Austad, Dale Wiegand, and George Evenson. We express our special appreciation to former committee member and Door County historian, the late Orv Schopf, for his help and inspiration.

Many people have been generous with their time and historical knowledge. We have two wonderful co-workers who helped us at every turn. Ginny Haen is a meticulous researcher, and we are very grateful for her assistance. Roger Schroeder not only permitted the use of his father's original photography, but also spent a great deal of time helping with descriptions. We could not have done this without him. Sally Treichel, of the Door County Archives, has researched, cataloged, and indexed more history than seems humanly possible. She helped us immensely throughout the process. June Larsen of the Door County Maritime Museum assisted us with maritime photographs and history. Paul Spanbauer shared his vast knowledge of the Ahnapee and Western Railroad. John Thenell was an invaluable resource for the chapter on orchards. We appreciate our brilliant readers, George Evenson, Sally Treichel, Jeff Weir, and Tom Zwicky for their attention to detail. We thank our editor, Ann Marie Lonsdale, for her help and support and Arcadia Publishing for its backing of this project.

Numerous other people shared images and information for this book, including Marlene Allen, Ron Amos, Ron Berg, Philip Berndt, Carl Bridenhagen, Terry Bubnik, Mike and Barb Chisholm, Russ Cihlar, Wayne Eastman, Nancy Emery, Mark Feuerstein, Harold and Mark Forbes, LaVerne "Mike" Gagnon, Bill and Gretel Goettelman, Ralph Herlache, Dick Hitt, Sonnie Jensen, Joe Knaapen, Richard Lauder, Joe Maggle, Janet Nicholson, Matt Orthober, Jim Pichette, Georgia Rankin, Tom Reynolds, Mark Schuster, Clyde Smith, Frank Tachovsky, Eric Volrath, Christie Weber, Gordon Weber, the Wisconsin Historical Society, and all of the people who have donated photographs to the museum throughout its existence.

Some of our sources include the following:
The Door County Advocate, "Diamond Anniversary Issue," March 26, 1937,
The Door County Advocate, "Centennial Issue," March 22, 1962,
The Door County Advocate, "Sturgeon Bay Centennial Issue," June 10, 1976,
The Door County Advocate, "Frontiers and Pioneers," March 12, 1999.
Holand, Hjalmar R. *History of Door County, Wisconsin: Volume I and II*. Chicago: S. J. Clarke
 Publishing Company, 1917

INTRODUCTION

The history of the city began when Oliver Perry Graham built the first log cabin on the east shore of Sturgeon Bay in 1850. Soon after, other settlers and their aspiring businesses started to mold the land surrounding the long bay that divides the Door Peninsula in half.

At that time, the body of water was known as Big Sturgeon Bay, as opposed to Little Sturgeon Bay, which was a few miles to the south along Green Bay. The French explorer, Fr. Claude Allouez, who wintered with the Pottawatomie in 1676, was the first to write "La Portage des Eturgeons," apparently referring to the plentiful sturgeon in the bay.

Industries, using the abundant natural resources of the area, made their marks along the shores. Sawmills processed the bounty of the thick forests that grew in the vicinity of the future city. Their workers loaded schooners with pine, cedar, and hemlock for use in the growing cities of the developing midwest. A small community rose on each side of the bay to support the mills.

At the same time, stone quarry operations began harvesting the native limestone that constitutes Door County's bedrock. The market was ripe for stone needed in harbor improvements at many ports on Lake Michigan and later railroads and roads. In addition, clean, deep ice was cut from the waters of Sturgeon Bay and stored in huge icehouses until it could be shipped to meatpackers in Chicago and breweries in Milwaukee.

The villages growing on the Sturgeon Bay shore were known by several names. In these early days of the 1850s, the east side was known as Graham, after the first settler. A common practice of the time was to name a village after an exotic place found in the news. The young village soon became known as Otumba, after a resident heard of an Aztec city in Mexico of that name. The west side was first known as Bay View, an accurate description of the village nestled along the shore. As post offices were established on both sides, the modern names were chosen. The east side became Sturgeon Bay, and the west side became Sawyer, named after Congressman Philetus Sawyer. Sawyer was annexed to the young City of Sturgeon Bay in 1894, creating one united city split in half by the bay.

The year was 1873. The first shovels of dirt were scooped out of the cleared swath of land to make way for the ship canal. This engineering feat, which many felt was impossible, changed the course of history in Sturgeon Bay. Completed in 1882, the man-made waterway linked the waters of Green Bay and Lake Michigan. Suddenly, the long bay leading up to the canal became a major shipping passage. The success of the canal project boosted local industry and paved the way for new business endeavors.

The lumber business waned as the county forests diminished. But with the beginning of the

20th century, a new industry took the sawmills' place on the waterfront—shipbuilding. By 1907, three separate boatyards were repairing and building watercraft along the Sturgeon Bay shore. During World War II, all the shipyards were called into action. Workers flooded into the city to help with the wartime production of ships. The small city grew and strained under immense pressure to meet the demands of the war effort. The people of Sturgeon Bay met the challenge and felt pride for all they accomplished. When the war ended, the shipyards continued to flourish. They adjusted to build commercial, military, and luxury vessels for a peacetime economy. The remaining shipyards continue to provide an important role in the local economy and lend a unique maritime character to the city.

As industry grew along the waterfront, an agricultural phenomenon was taking place on the land in and around Sturgeon Bay. Cherry trees were planted in record numbers after it was learned that the unique climate on the peninsula and mineral rich soils were suited to growing fruit. As the crop grew in size, packing plants sprang into operation. Some ingenious marketing by local promoters made Sturgeon Bay cherries famous throughout the nation. During the 1930s and 1940s, growing, picking, packing, and marketing were all a part of the heyday of the fruit industry that made a permanent mark on Sturgeon Bay.

Although enterprising industrialists found business success, there is no doubt that the allure of our little city is tied to the spectacular splendor that surrounds us. Visitors have found the beauty of the shores and woodland in and around Sturgeon Bay to be a natural place of refuge for over 100 years. In the early days, they arrived by steamship, ready to vacation at one of the tourist hotels or waterfront resorts. Although the preferred mode of transportation is now the automobile, visitors continue to find a peaceful retreat in the charming, small city that lies on both sides of the long bay in the middle of the Door Peninsula.

One

BEGINNINGS

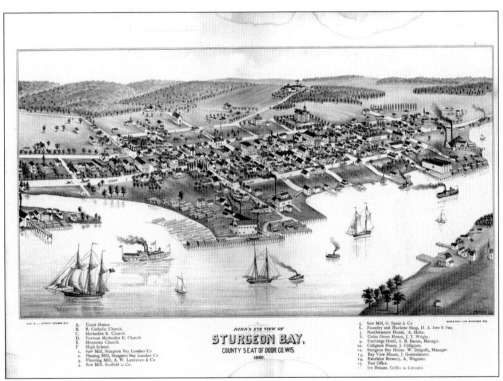

This is an artist's rendition of a bird's-eye view of Sturgeon Bay in 1880. In just 30 years, the village had been transformed from a pine forest to the bustling county seat of Door County with its abundance of sawmills. The business district was already established on Cedar Street (Third Avenue), and the courthouse stood on the outskirts of the community. Stone quarries, lime kilns, and ice operations all fed into the burgeoning city's economy. New immigrants and established entrepreneurs found opportunity in the developing community on the waters of Sturgeon Bay.

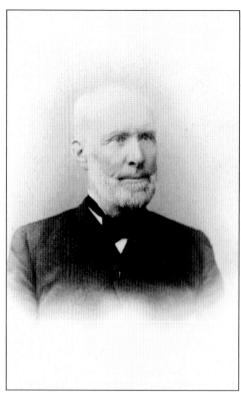

Charles Scofield (1827–1891) was a pioneer mill operator and one of the county's most prominent lumbermen. He operated mills in Red River, Tornado (after the great fire of 1871), and Sturgeon Bay with two other Sturgeon Bay pioneers, John Leathem and Thomas Smith. When Sturgeon Bay was incorporated as a city in 1883, Scofield was elected its first mayor.

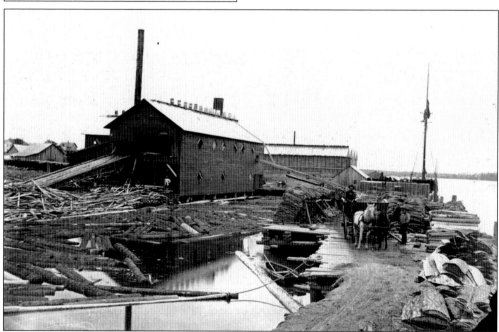

Scofield and Company Sawmill, shown in 1878, was one of many sawmills that dotted the shore during the early development of Sturgeon Bay. It was located on the shore between Kentucky and Jefferson Streets. Notice the row of wooden barrels that caught rain water for use in the event of a fire in the mill.

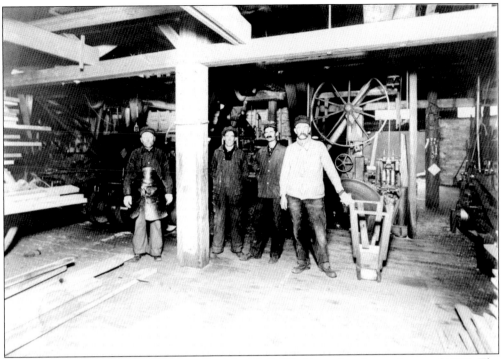

These workers pose at the planing mill of the N. S. Washburn Lumberyard around 1925. The mill was located at the foot of Kentucky Street next to the toll bridge. From left to right are Joe Krause, William Losli, Frank Bonnes, and Otto Erdmann.

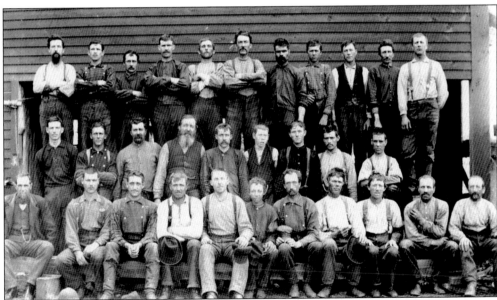

These are the mill workers at the L. M. Washburn Lumber Company in 1884. The many sawmills and lumber companies provided steady jobs for immigrants. As time wore on, the mills diminished and other industries such as agriculture and shipbuilding took over.

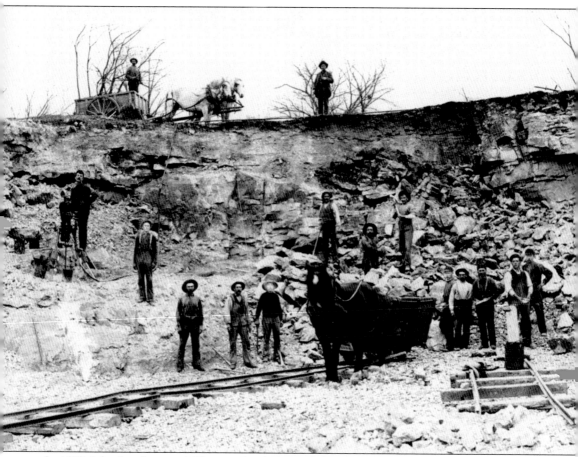

In 1893, John Leathem and Thomas Smith opened the above quarry on the east shore at the mouth of the bay. This soon became the largest crushed-stone plant in the state. The late Stanley Greene is quoted here by his writing in *The Door County Advocate* in 1976: "The first indelible marks that the white man left on the shores of Sturgeon Bay were the scars of his quarrying. Over a period of 145 years, those scars were extended from Hibbard's Bluff on the east shore up the bay to the east side of Big Creek; on the west shore, from Government Bluff (in Potawatomi Park) up past the foot of Hickory Street. Ugly? Perhaps, but not when one considers what came out of them. Their stone made some of the finest harbors on Lake Michigan, built hundreds of beautiful and enduring buildings on both its shores, and helped to make smooth and firm the advent of the Automobile Age."

John Laurie (1862–1947) opened the Laurie Stone Quarry along with his father, Robert, north of the village along the bay shore. As highway commissioner, John established the first macadamized roads (paved with small broken stones and bound with tar or asphalt) in the county and was known as the "father of modern highway development."

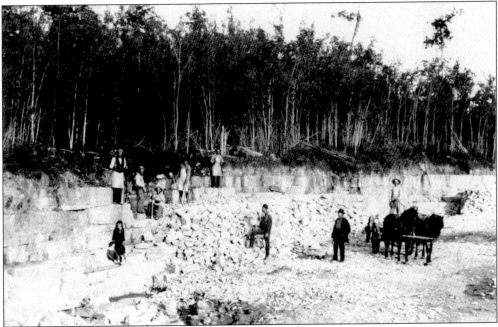

Workers pose at the face of the Laurie Stone Quarry. When this quarry opened in 1880, the work was done with manpowered hammers, wedges, and crowbars. Five years later, blasting powder eased some of the muscular work. Stone from this quarry was used in the basements and foundations of A. W. Lawrence's business block (the site of the present day Younkers Store).

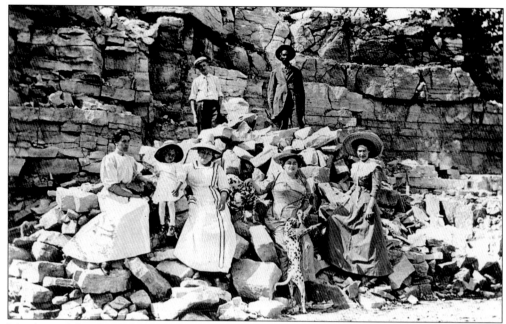

Members of the Green family pose in their quarry along with Peter Custis. Custis, in the back on the right, was a former slave who settled in Sturgeon Bay after the Civil War. The Green Stone and Quarrying Company was located just north of Hickory Street. (Photograph courtesy of Marlene Allen.)

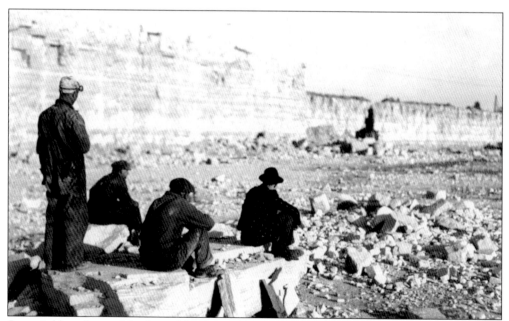

Stone is blasted out of the face of the former Leathem and Smith Quarry in the 1930s. Thomas Smith's son Leathem Smith took over the quarry in 1914. This business grew to the point of employing a crew of 100 men and shipping 600,000 tons of crushed stone. The stone was shipped via a fleet of nine ships equipped with scraper type self-unloading devices Leathem Smith designed himself. (Original photography by W. C. Schroeder.)

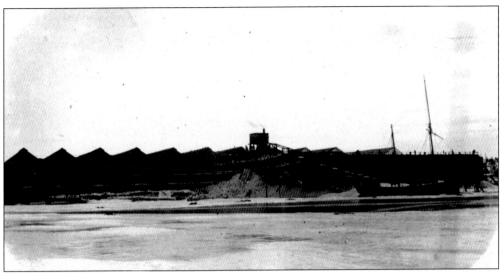

The George H. Hammond Company's 15 ice houses were on the west shore near the present- day Bay View Park. By 1880, six ice companies had immense storehouses in and near Sturgeon Bay. The ice was stored and covered with sawdust until it could be shipped by schooner in the spring. Hundreds of workers, mostly farmers, were employed during the two to three month ice harvest.

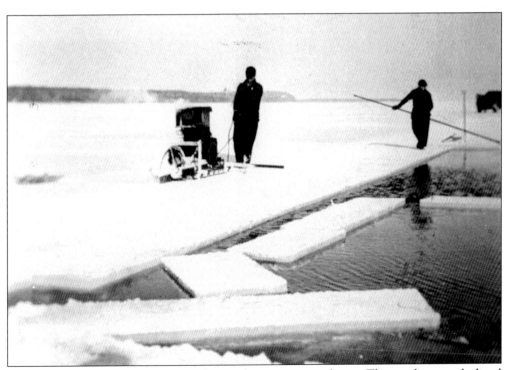

These men are cutting ice on the bay with a gas-powered saw. The ice harvest declined considerably by 1890. Competing operations with access to rail service could ship by rail directly from the ice fields to the big city storehouses. The ice industry continued in Sturgeon Bay on a smaller scale, supplying the local market well into the 1930s.

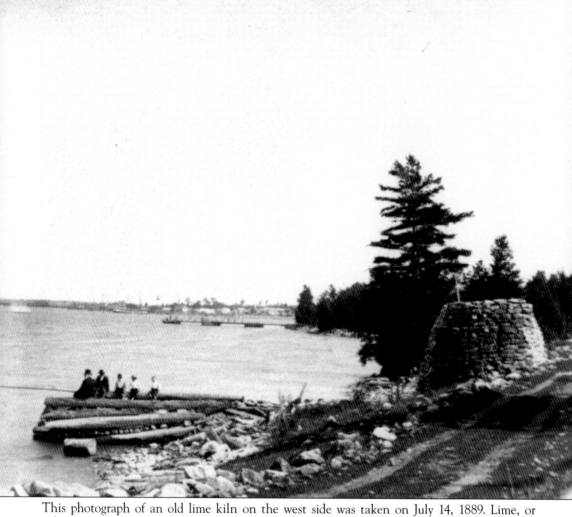

This photograph of an old lime kiln on the west side was taken on July 14, 1889. Lime, or calcium oxide, was an important export in the early days of settlement. It was obtained by heating limestone and was used for mortar, plaster, and cement. Kilns were built out of the native limestone. Stone was fed into the top and wood fires at the bottom cooked the stone for several hours. The finished product was hauled out of the oven in the form of white chips that would be crushed into powder.

James Pinney is shown with his surveyor's theodolite and tripod. Pinney, a Civil War veteran, participated in Sherman's march to the sea and survived imprisonment at the notorious Andersonville Prison. After the war, he came to Sturgeon Bay to assist his brother George with Evergreen Nursery. He later became the county surveyor, as well as city assessor and justice of the peace.

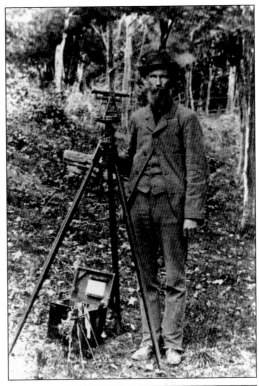

George Pinney's house, surrounded by nursery stock, was built in 1887 on the property of Evergreen Nursery. Pinney, a Methodist preacher, came to Sturgeon Bay in 1864 and started collecting and selling native trees and shrubs. The nursery moved in 1876 to the present location. It is the second oldest business in the county. (Photograph courtesy of Evergreen Nursery.)

Joseph Harris was born in London, England, in 1813 and came to Sturgeon Bay in 1855. He took employment as a bookkeeper for Graham Brothers sawmill. He established a long record of public service, holding many offices, such as local register of deeds, postmaster, county clerk, and state senator. In 1863, he went to Washington and worked as secretary to Senator Philetus Sawyer. (The west side of Sturgeon Bay was originally called Sawyer after the senator.) Perhaps best known as the founder of *The Door County Advocate*, Harris considered his greatest achievement to be the completion of the Sturgeon Bay ship canal. He organized supporters, raised funds, and lobbied for land grants from state and federal authorities. His dream came true after 22 years when, in 1878, the waters of Sturgeon Bay and Lake Michigan met for the first time. Harris had 10 children by his two wives, Charlotte Singleton and Susan Perkins. His son Arthur, grandson Sumner, and great-grandson Chan all served as editors of *The Door County Advocate*.

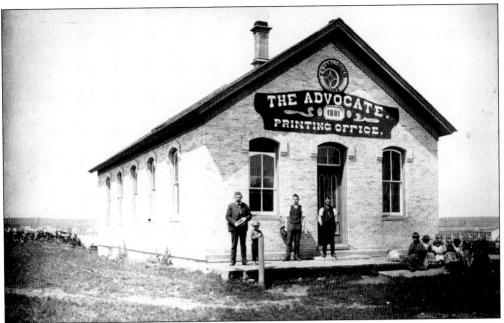

The Door County Advocate, founded by Joseph Harris in 1862, was the first newspaper and is the oldest business in Door County. This location, at the southwest corner of Michigan Street and Second Avenue, was the paper's second location. Although there have been several competing papers over the years, *The Door County Advocate* has endured where others failed.

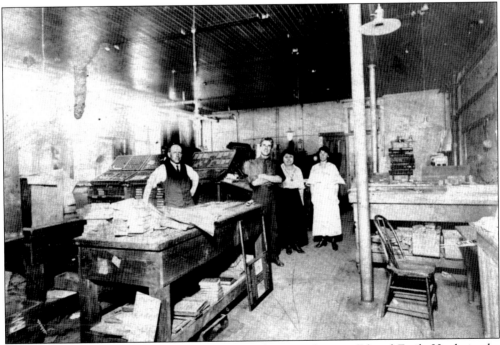

Here is an interior shot of The Door County Advocate, showing Ed and Emily Houle in the center. Ed Houle had been an owner of a competing paper, *The Door County Democrat*, along with H. J. Sanderson and A. T. Harris. In 1918, they bought *The Door County Advocate*.

STURGEON BAY MILESTONES

Oct. 27, 1674—Father James Marquette, missionary and explorer, stopped here for three months on his way south.

Oct. 1676—Father Allouez, first missionary of the West, spent the winter with the Potawatomi Indians here on his way south. He was the first to mention the name of Sturgeon Bay, writing "LaPortage des Sturgeons."

1825—H. B. Culpin, fur trader, ran the first post here.

1835—Increase Claflin, fur trader, became the first permanent settler of Door county. He settled at Sturgeon Bay but soon changed his location to Little Sturgeon.

Aug. 14, 1849—Perry O. Graham entered claim to a tract of land now in Sturgeon Bay's business district, becoming the first permanent settler here.

1851—Graham built the first house in the future city, just southwest of what is now Martin park.

1853—Lyman Bradley and D. S. Crandall of New York state built the first sawmill here.

1855—Graham became Sturgeon Bay's first merchant, running a store in connection with his boarding house.

Aug. 10, 1855—First village plat recorded by Robert Graham, brother of Perry Graham.

November, 1855—First election was held in Sturgeon Bay. The voting was for governor of the state.

1856—Soren Peterson put up the city's first hotel, located on the site of the present Holiday Motel.

March 22, 1862—First newspaper, the Door County Advocate, founded here by Joseph Harris, Sr.

1862—The Moravians built the first church in Sturgeon Bay.

1864—The charter for the Sturgeon Bay-Lake Michigan ship canal was framed in the legislature by Joseph Harris, Sr., first state senator from this district.

1874—Sturgeon Bay was first incorporated as a village.

1882—Canal opened for business.

April 3, 1883—Charter for the city Sturgeon Bay granted by the legislature.

April 7, 1883—Sturgeon Bay became a city upon official publication of its charter.

April 17, 1883—The city of Sturgeon Bay's first election of officers was held.

1884—First bridge across Sturgeon Bay was begun by Leathem and Smith. The bridge was chartered two years later and officially completed in 1887.

1891—Sawyer annexed as the fourth ward of the City.

Aug. 9, 1894—Railroad arrived on the east side after having served Sawyer since the preceding July 23rd.

July 4, 1931—First highway bridge across Sturgeon Bay was dedicated.

Oct. 21, 1960—Bridge struck by freighter, out of commission for 18 days, spurring demand for new bridge which culminated in start of construction in 1976.

1964—New hospital completed. Floor added in 1970.

1967—Classes begin in new Sturgeon Bay senior high school.

March 1969—National Geographic article on Door county giant spur to tourism and industrial expansion.

1971-72—Manitowoc Shipbuilding Co. moves to Sturgeon Bay followed by near 10-fold increase in employment at yards acquired.

These milestones were printed in *The Door County Advocate*'s Sturgeon Bay Centennial Issue on June 10, 1976.

Two

CROSSING THE WATER

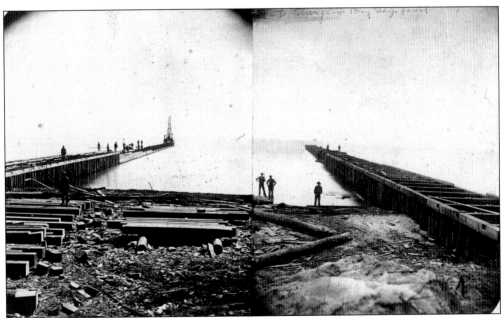

These are views of the harbor piers at the entrance to the Sturgeon Bay ship canal while under construction on September 15, 1873. The canal opened up a shipping passage that made Sturgeon Bay a vital waterfront community. The requisite lighthouses and range lights aided the shipping passage. Docks for loading freight and depositing tourists soon developed along the shores of Sturgeon Bay. Ferries and then bridges linked the communities that developed on both sides of the bay. Eventually, even rail service was carried across the bay. The ease of passage allowed both sides to be incorporated together as one city.

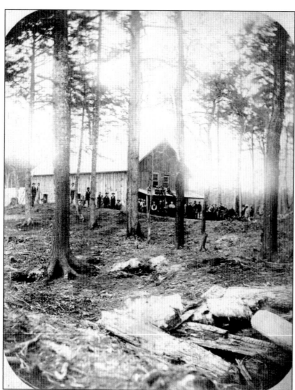

Canal workers stayed at this rooming house in the vicinity of the ship canal during its construction. (Photograph courtesy of the Door County Archives.)

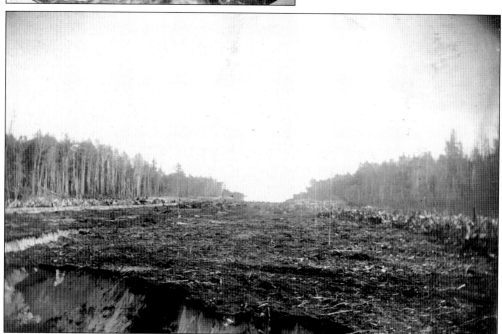

The course of the canal is shown after the felling of trees in 1872. Six years later, in 1878, a great celebration marked the meeting of the waters of Lake Michigan and Sturgeon Bay. Excavation continued, and by 1880, the canal was open for light draft vessels, and in 1882, it was open for full navigation.

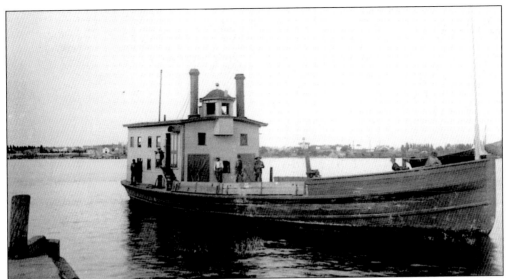

The County gave Robert Noble a 10-year charter to operate a steam ferry across Sturgeon Bay before there was a bridge. Noble charged 20¢ for one span of horses or oxen, wagon, and driver; and 5¢ for foot passengers. Noble's first ferry, *The Ark*, was commissioned in the spring of 1874, followed by the larger *Robert Noble*, pictured here.

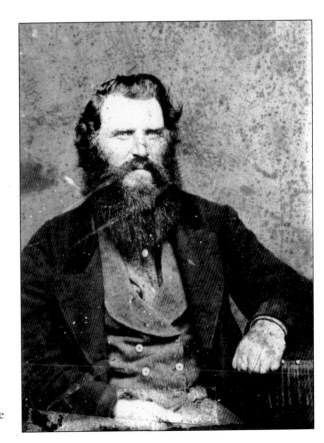

Robert Noble came to Door County in 1855. On New Year's Day in 1864, while crossing "Death's Door" in a small boat, he froze his hands and feet. After months of agony, his legs were amputated below the knees. With no medical attention, his fingers rotted off. Despite this hardship, he went on to operate and pilot the ferry service in Sturgeon Bay.

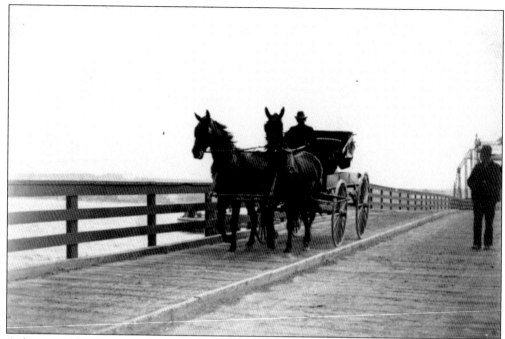

A driver and his team cross the new toll bridge. The toll bridge that spanned the bay was built in 1887 by two local lumbermen, John Leathem and Tom Smith, along with Rufus B. Kellogg of Green Bay. These men knew the lumber business was dying and were seeking another investment opportunity. They were given a 25-year charter for the exclusive operation of the bridge.

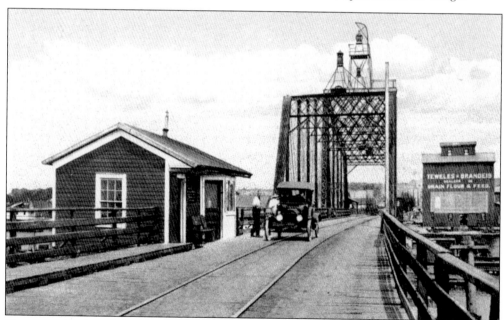

Upon termination of the 25-year charter in 1911, the bridge was turned over to the city. Some people did not take kindly to paying the toll and followed the practice of using Mother Nature's "free bridge" during the winter. Eventually, the toll charges were taken off when the bay was iced over. (Photograph courtesy of Paul Spanbauer.)

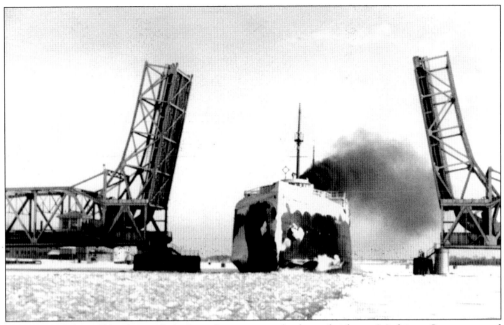

The days of the toll bridge ended when the new state highway bridge at Michigan Street opened on July 4, 1931. Here the car ferry *Wabash* passes through the draw in 1939. This bridge was placed on the National Historic Register in 2006 in recognition of its unique Scherzer type counterweighted rolling lift bascule span. (Original photography by W. C. Schroeder.)

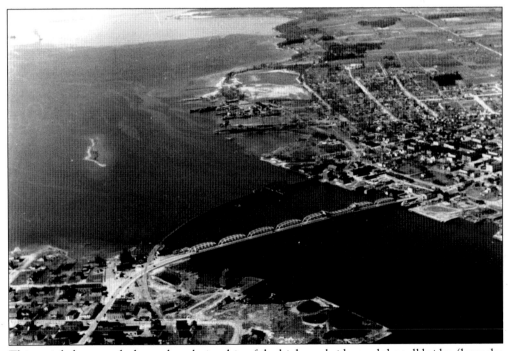

This aerial photograph shows the relationship of the highway bridge and the toll bridge (later the railroad bridge) as they span the two sides of Sturgeon Bay. Notice the shallow reef to the north, where the Dunlap Reef range lights once stood. (Original photography by W. C. Schroeder.)

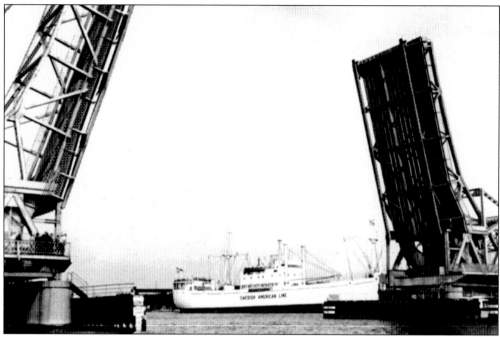

On October 21, 1960, at 10:30 a.m., the sharp bow of the Swedish freighter *Carlshom* knifed into the draw of the Sturgeon Bay highway bridge, putting the bridge out of commission and slicing Door County and Sturgeon Bay in two. That evening, Capt. Arni Richter of Washington Island arrived with two car ferries. His weary crews worked 24 hours a day shuttling traffic across the bay. Peterson Builders rushed work on a temporary barge bridge at the ship canal. County crews ripped the approaches through woodland and sand banks. On October 30, the temporary bridge was completed, ending the need for ferry service. On November 9, skilled crews from the Sturgeon Bay Shipbuilding and Dry Dock Company completed repairs to the highway bridge. (Original photography by Herb Reynolds.)

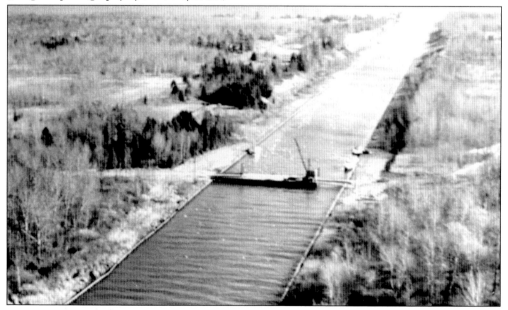

In 1894, when the Ahnapee and Western Railway finally came to Sturgeon Bay, the tracks were built on the existing toll bridge structure. A heavier draw was constructed, and new approaches for the trains were built. This bridge handled all traffic until the highway bridge opened in 1931. The older bridge was then used exclusively for the railroad.

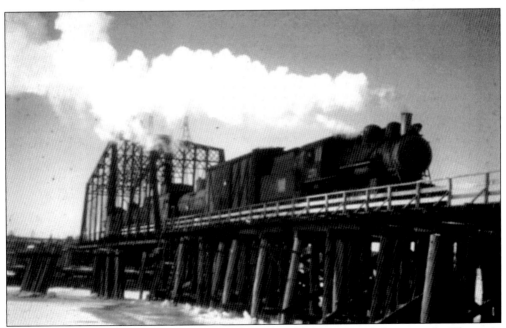

Engine No. 251, built in 1914, crosses over the railroad bridge toward the east side. The train never went north of Sturgeon Bay's east side, terminating at a turntable near the shipyard north of the depot on Third Avenue. The railroad was in business in Sturgeon Bay for 74 years, providing service to the Evangeline Milk Condensery, Fruit Growers Cooperative, the shipyards, and other businesses, as well as passengers.

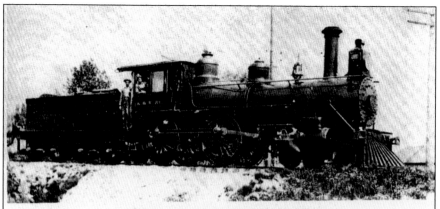

AHNAPEE AND WESTERN ENGINE NUMBER 72

AHNAPEE & WESTERN R'Y.

TIME TABLE

After Sunday, November 13th., 1892.

Ahnapee to Green Bay.

LEAVE AHNAPEE.	LEAVE CASCO JUNCTION.	ARRIVE AT GREEN BAY.
9:00 A. M.	10:20 A. M.	11:45 A. M.
5:00 P. M.	6:07 P. M.	7:15 P. M.

Green Bay to Ahnapee.

LEAVE GREEN BAY.	LEAVE CASCO JUNCTION.	ARRIVE AT AHNAPEE.
6:45 A. M.	7:50 A. M.	8:40 A. M.
2:15 P. M.	3:40 P. M.	4:50 P. M.

Ahnapee to Kewaunee.

LEAVE AHNAPEE.	LEAVE CASCO JUNCTION.	ARRIVE AT KEWAUNEE.
6:50 A. M.	7:50 A. M.	8:25 A. M.
2:40 P. M.	3:40 P. M.	4:30 P. M.

Kewaunee to Ahnapee.

Leave Kewaunee.	Leave Casco Junction.	Arrive at Ahnapee.
9:30 A. M.	10:20 A. M.	11:30 A. M.
5:30 P. M.	6:07 P. M.	6:50 P. M

Above is an Ahnapee and Western schedule before the connection to Sturgeon Bay was completed. At this time in 1892, Ahnapee (Algoma) was the end of the line. A fair amount of controversy surrounded bringing the railroad to Sturgeon Bay. Some thought the railroad would cut down on use of the ship canal. It was difficult to raise either public or private funds to support a rail system when many felt there already was an excellent transportation system by boat. Finally, supporters of the railroad won, and the Ahnapee and Western Railway made its way to Sturgeon Bay. Door was the last county in Wisconsin to get rail service and also the first to lose rail service in 1969. (Photograph courtesy of Paul Spanbauer.)

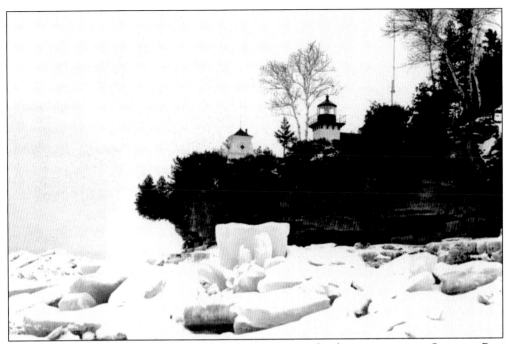

The icy scene shows Sherwood Point lighthouse as it marks the entrance into Sturgeon Bay. Constructed in 1883, it was the last manned U.S. Coast Guard light on the Great Lakes when it was automated 100 years later in 1983. (Original photography by W. C. Schroeder.)

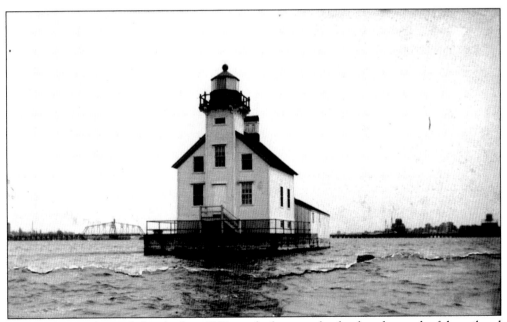

The Dunlap Reef range lights, built in 1881, perched on a rocky shoal to the north of the railroad bridge. This structure was the rear light in a pair that marked a navigational hazard for ships passing through Sturgeon Bay. In 1922, the structures were replaced with unmanned lights and buoys. The house was moved to Fourth Avenue, where it continues to serve as a private residence.

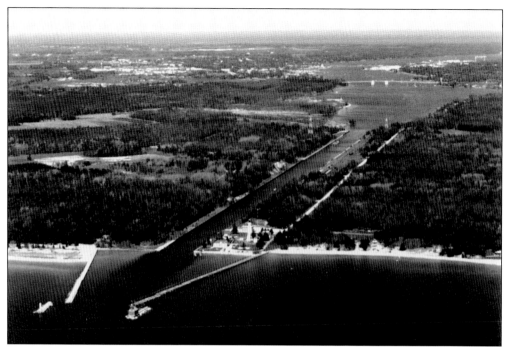

This modern aerial photograph shows the two piers at the entrance of the canal, along with the U.S. Coast Guard Canal Station. The mile-long canal, conceived by Joseph Harris Sr. and his supporters in the early days of Sturgeon Bay's development, has grown into a busy passage for commercial vessels and pleasure craft. (Original photography by Matt Orthober.)

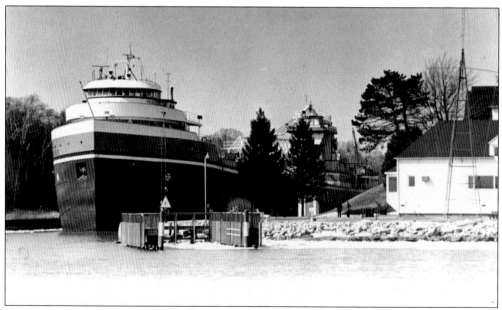

The steamer *Wilfred Sykes* passes through the canal. The Sturgeon Bay ship canal has borne witness to transformations in shipping from sailing schooners to the large 1,000-foot iron ore carriers that were built in Sturgeon Bay in the 1970s. (Photograph courtesy of the Door County Maritime Museum.)

Three

DOWNTOWN—EAST SIDE, WEST SIDE

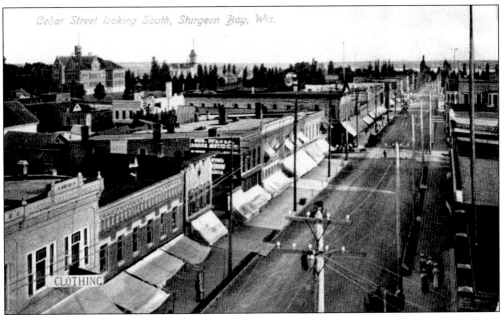

This view of Third Avenue (or Cedar Street) looks south with the old high school and courthouse in the left background. The original street names in Sturgeon Bay reflected its history. However, during World War II, the names were changed to allow the influx of workers to find their way through the city. The new names were numerical and alphabetical (states) on the east side and alphabetical (trees and cities) on the west side. A few examples of the changed names are as follows: First/Water, Second/Main, Third/Cedar, Fourth/Court, Jefferson/Garland, Kentucky/St. John, Louisiana/Cottage, Michigan/Spruce, Nebraska/Pine, and Madison/Union. Also lost were the street names Lawrence, Minor, Graham, Rieboldt, Tong, Reynolds, Haskell, Harris, Sorenson, and Jacobs. This book uses the modern street names to describe locations.

This photograph looks west down Michigan Street toward the new highway bridge in the 1930s. A coal-fired ship is passing through the draw. The Sturgeon Bay Cleaners, on the left, was once The Door County Advocate building. (Original photography by W. C. Schroeder.)

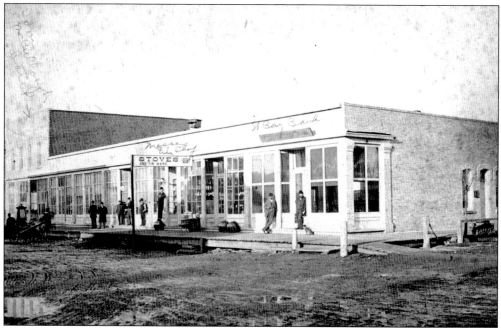

The intersection of Third Avenue and Michigan Street was once a muddy mess after a rain. The first bank in Door County, started in 1880 by F. J. Shimmel and Joseph Kozieshek, was on the corner. A number of banks used the facility until the new Merchants Exchange Bank was built on the site in 1908. The site now hosts the office of James Parson, CPA. (Photograph courtesy of Russ Cihlar.)

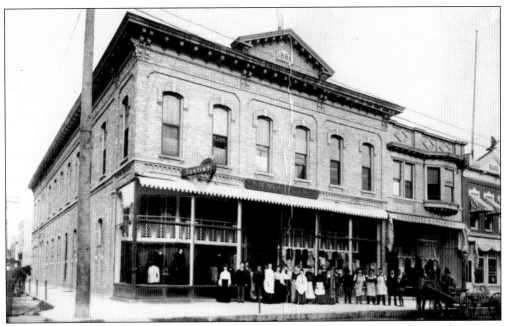

A. W. Lawrence and Company, built in 1880, was known as the county's first modern store. Later bought by Lawrence's son-in-law, L. M. Washburn, it was completely destroyed by fire in 1935. Washburn rebuilt the business before selling to the H. C. Prange Company in 1937. Now operating as Younkers, it remains at the corner of Third Avenue and Louisiana Street.

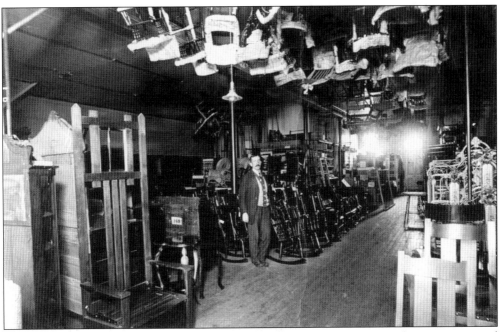

Henry Hahn stands among a variety of chairs on the floor and ceiling. His furniture store and undertaking business was located at 27–33 North Third Avenue. He built this structure in 1904 and lived above the business. Later, he and his wife, Emily (Shimmel), converted the upstairs to a modern funeral home and chapel.

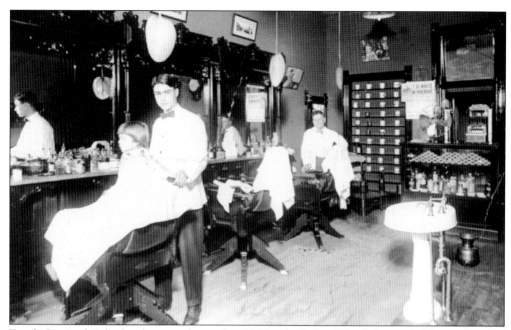

Frank Conjurski's barbershop was located at 12 North Cedar (Third Avenue). He was born in 1874 in Cologne, Germany, and came to Sturgeon Bay in 1900 after entering the barber trade. He and his wife, Florence, had eight children, most of whom became barbers or beauticians.

Conjurski was well known for his Nu-Life Hair Tonic, which treated all types of scalp conditions. He also claimed that it would restore gray hair to its natural color. In addition to this popular tonic in a blue bottle, Conjurski invented a four-unit stationary hair dryer, a face shield for shampooing, a shaving lotion applicator, and a tie and collar stay.

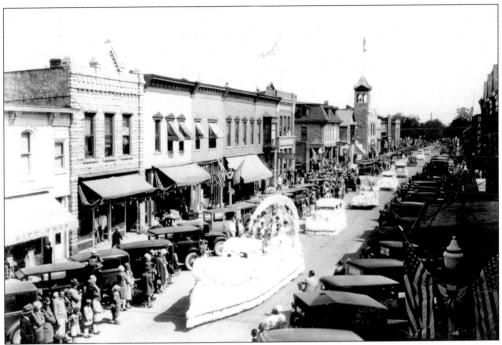

The queen's float, carrying Queen Marie Henkel and her court, leads the first Parade of Blossoms in 1929. The Cherry Blossom Festival weekend also included a historical pageant, the Cherry Blossom Ball, tours through orchards, and the dedication of Cherryland Airport.

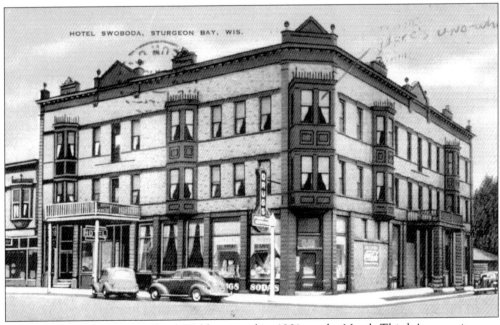

The impressive three-story Hotel Waldo opened in 1901 on the North Third Avenue site now occupied by Associated Bank. In 1917, Thomas Swoboda and Robert Schoenbrunn purchased the building, a downtown landmark for many years, and changed the name to the Swoboda Hotel. Bohn's Drug Store, with a soda fountain, occupied space on the ground floor.

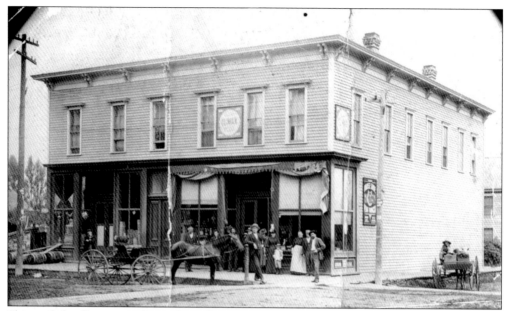

Shimmel the Grocer was located on the corner of Third Avenue and Kentucky Street where the Baylake Bank Conference Center Courtyard is today. The store was opened by Frank and Henry Shimmel in 1894 and remained in business until 1928, when the building was bought by George and Margaret DesEnfants and was remodeled into the Hotel Roxana. (Photograph courtesy of Clyde Smith.)

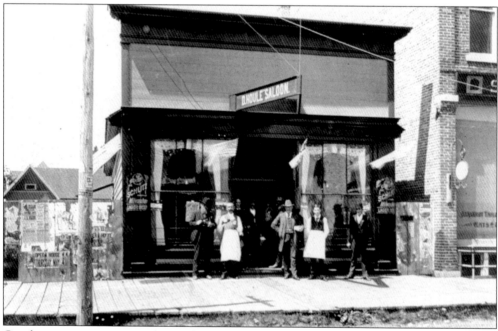

Gentlemen pose on a sunny day on the boardwalk in front of the David Houle Saloon, located on the site of the Brick Alley on North Third Avenue. The saloon was bought out by Arnold Wagener who, in 1916, advertised, "Buffet and Billiards, Imported and Domestic Liquors, Cigars and Tobacco."

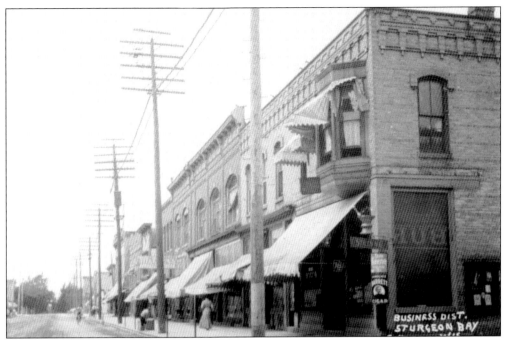

This postcard view of Third Avenue (Cedar Street) shows the east side of the block from Louisiana Street to Kentucky Street in August 1911. Today, the building on the corner houses the Inn at Cedar Crossing.

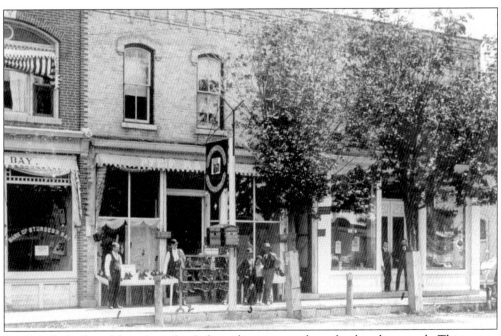

A sidewalk display of shoes brought clerks and patrons outdoors for this photograph. This corner building, now the Inn at Cedar Crossing, was built in 1885. A. W. Lawrence opened a shoe store in the left storefront in 1896. The Henry Stiles Drug Store occupied the right side starting in 1890. Hester Laurie Hansen, the first woman pharmacist in Wisconsin, worked there in 1907.

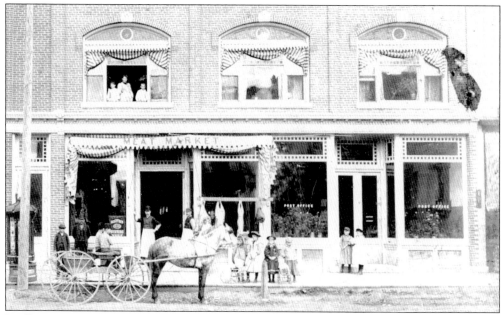

Dudley Lawrence operated this meat market on Third Avenue that served three generations of the family, being passed on to Ruth and Carl Fischer and then Sonnie and James Jensen. This building was vacated when they built the new Fischer's Super Value across from the Peterson Pool in 1968. The original building, with its distinctive upper windows, currently houses Wilkins and Olander. (Photograph courtesy of Sonnie Jensen.)

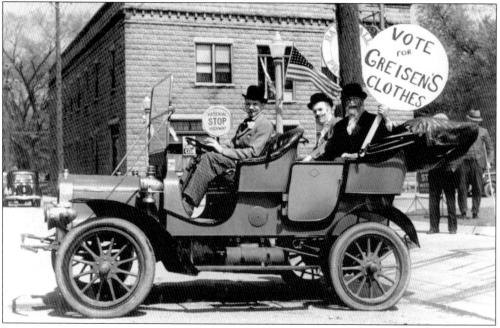

A parade was an occasion to don old-time dress and ride in an old 1907 Buick. Greisen's Dry Goods and Clothing was a long-standing business on Third Avenue where Door Country Gifts operates today. Built by Charles and Mercy (Dunlap) Greisen in 1895, the building still bears the Greisen name. (Original photography by W. C. Schroeder.)

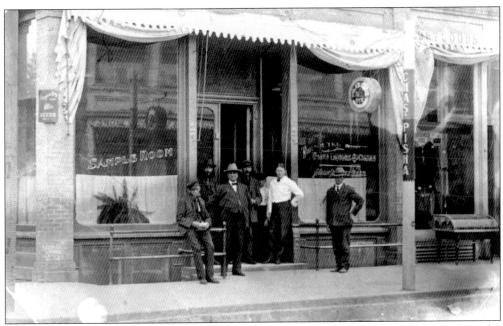

These gentlemen stepped outside of Charles Pisha's tavern, called the "Sample Room," on the corner of Third Avenue and Kentucky Street, now housing Poh's Corner. On the left in the front is Andrew Hartl next to John Graf wearing the large hat. The man with the white shirt is the owner, Charles Pisha. Also in the photograph are a Mr. Jenson, George Champeau, and Ole Olson. Below, a group of patrons pose inside the Sample Room, with Charles Pisha behind the bar. (Photos courtesy of Terry Bubnik.)

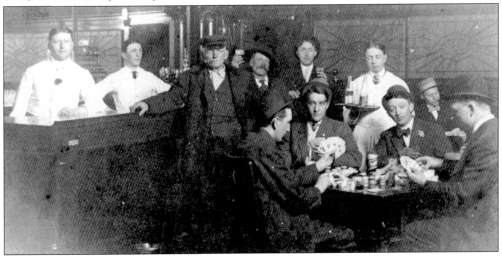

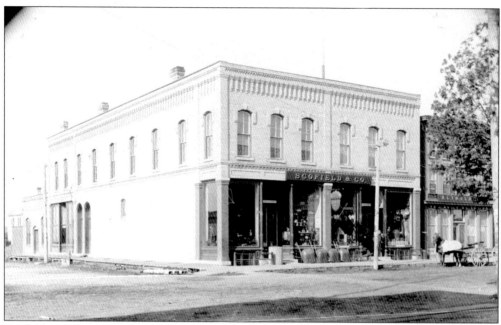

Scofield and Company Hardware inhabited this corner of Third Avenue and Louisiana Street starting in 1888. After the brothers Bert and Harry Scofield built a new building in 1903, Halstead and Maples Hardware took over this location, followed by Bunda's Department Store. The building now houses the Pudgy Seagull restaurant and FLS Banners.

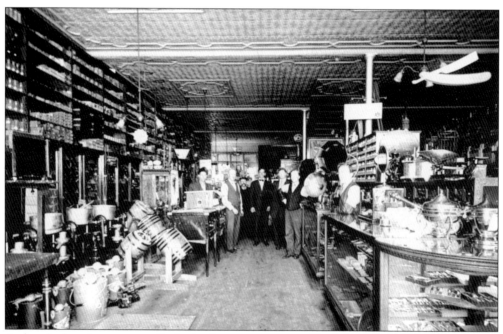

A close look at the wares on display in this interior view of Scofield Hardware shows household items such as churns, ice cream makers, clocks, and scales. Inside the glass counter are an array of silver serving pieces and silverware. The two men on the far right flank the large horns that attached to phonographs of the day.

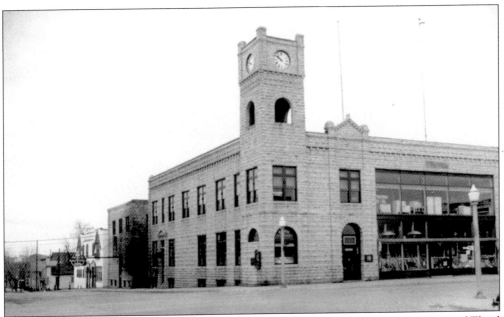

The Bank of Sturgeon Bay built this impressive gray limestone structure on the corner of Third Avenue and Kentucky Street in 1900. In 1955, the bank expanded into the "Scofield Block," the adjacent building on the right. The clock tower was removed in 1939 for safety reasons. In 1989, the bank retrieved the old bell and built a modern rendition of the old clock tower across the street. (Photograph courtesy of W. C. Schroeder.)

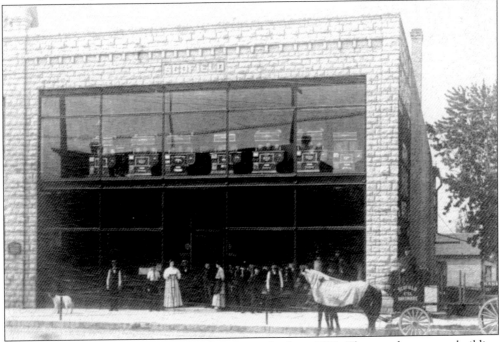

The "Scofield Block" was the new hardware store built in 1903. The grand two-story building with huge display windows shows Monarch cook stoves on the upper level. Notice the horse pulling a Scofield delivery wagon. The building is now Harmann Studios.

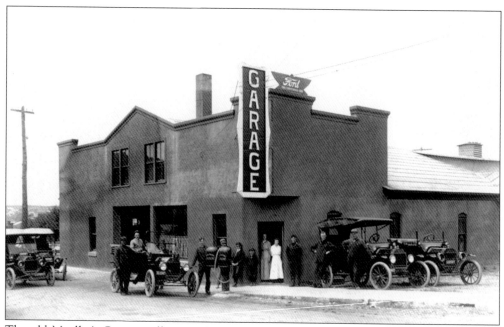

The old Moeller's Garage, selling Ford automobiles, was located behind the Union Hotel on Jefferson Street between Second and Third Avenues. This was originally Moeller's Livery, which served the hotel guests. By 1921, the garage had moved up the street into the old Crystal Theater building. (Photograph courtesy of Ginny Haen.)

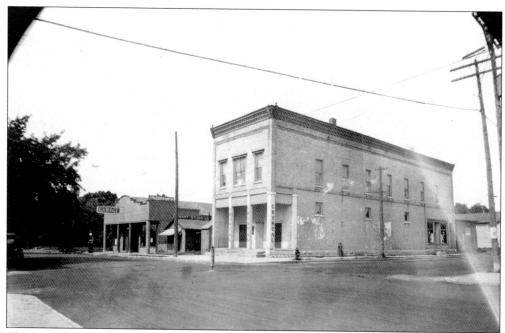

The Crystal Theater stood on the corner of Third Avenue and Jefferson Street. In 1916, the proprietor was Harvey J. Stock, who advertised the theater for relaxation and enjoyment with all the latest films. In those days, the movies featured the stars of the silent screen. (Photograph courtesy of Ginny Haen.)

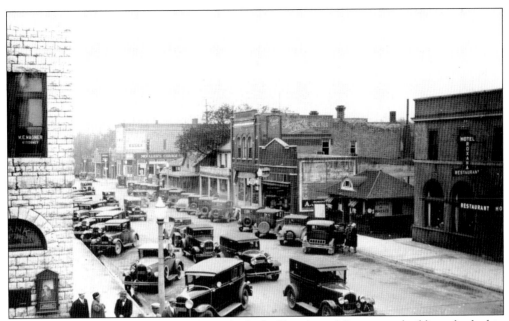

This view of North Third Avenue shows the little Chamber of Commerce building plunked in between the Hotel Roxana and Wiest and Sons Plumbing. Notice the diagonal parking that was in effect for many years until after World War II.

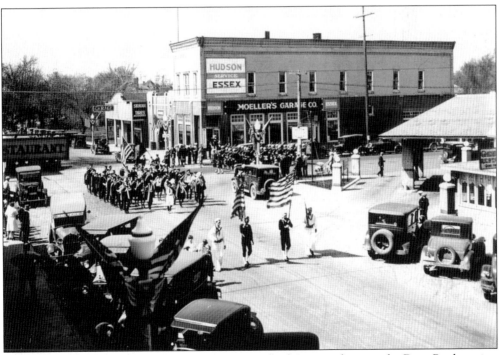

A parade rounds the corner of Jefferson Street to Third Avenue showing the Deep Rock station where Door County Ace Hardware sits today. Moeller's Garage across the street sold Hudsen and Essex Motor Cars during this period, around 1930. Moeller's remained in business on that site until 1998. The building was demolished in 2000.

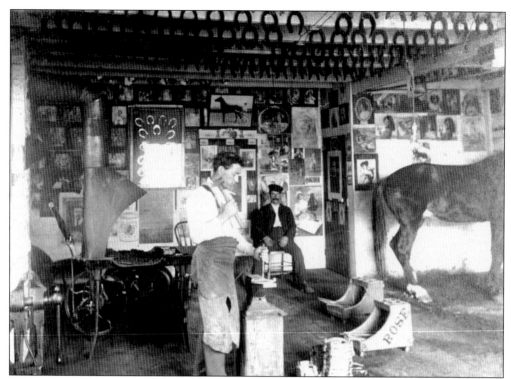

Victor Rose (1870–1960) makes horseshoes in his South Second Avenue blacksmith shop in this c. 1890 photograph. Blacksmithing was an essential occupation. In addition to the farrier's business of shoeing horses, most blacksmiths spent long days hammering red hot iron into an assortment of tools necessary for daily life.

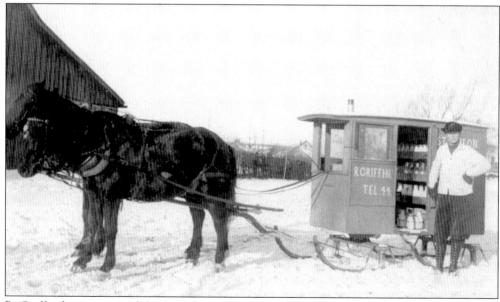

R. Griffon has a team and sleigh ready to deliver milk. This photograph was taken around 1907 on Second Avenue in front of the Hotel Bhirdo on the site of the present Holiday Hotel.

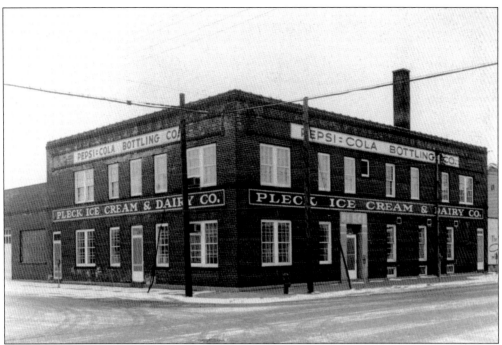

In 1891, Frank Pleck was the first to manufacture soft drinks in Door County from a little plant in the basement of a store. Over the years, his business grew into a thriving dairy and soft drink business. Shown here is the modern plant built in 1924 on the corner of Fourth Avenue and Jefferson Street. Pleck's Dairy was the first to pasteurize milk in Sturgeon Bay and pioneered in the manufacture of ice cream and butter. By 1948, there were 45 year-round employees and 65 summer employees making deliveries with a fleet of 20 trucks. The site of the plant is now a parking lot for Baylake Bank.

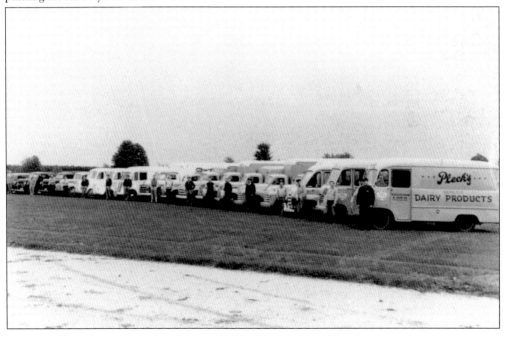

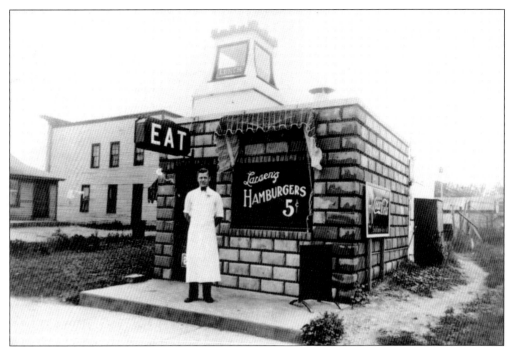

Lawrence Larsen stands in front of the little 5¢ hamburger joint that he and his brother, Eugene, built in 1932. With only five or six stools on the inside, they would have customers lined up outside for both breakfast and lunch. Due to the great volume of business, the brothers built the new restaurant next door in 1934 and operated it until they both volunteered for service in 1942. Their motto was, "Crunch with the bunch at Larsen's Lunch." Today the building is occupied by Perry's Cherry Diner. (Original photography—lower photograph—by W. C. Schroeder.)

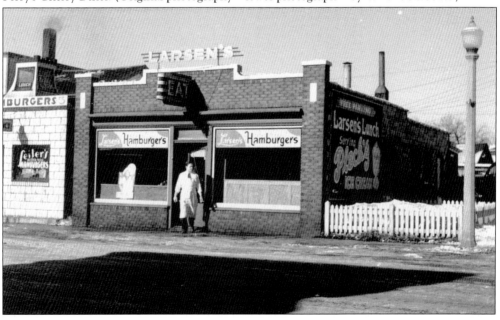

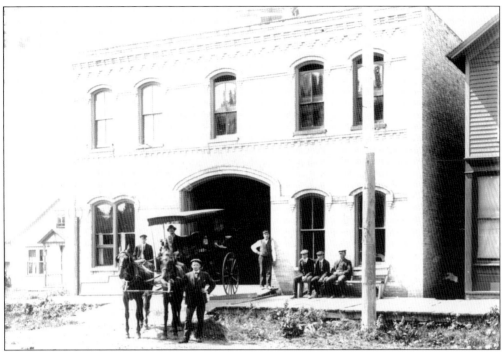

This livery on South Third Avenue belonged to George Rankin Sr., standing near the doorway. George operated the livery stable and housed the fire horses and fire wagon for the city. After the days of horse and buggy slipped away, his son George Jr. operated Rankin Tractor Sales out of the same location. The building remains today as the home of Lakeshore CAP, Incorporated.

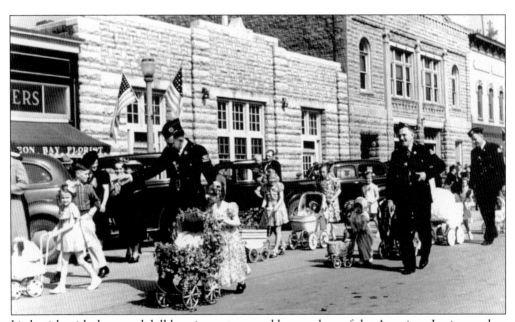

Little girls with decorated doll buggies are escorted by members of the American Legion as they march past the fire station and city hall around 1938. Children with decorated doll buggies or bicycles were a highlight of Sturgeon Bay's parades. (Original photography by W. C. Schroeder.)

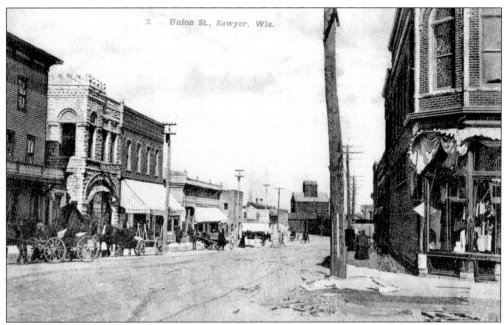

A postcard shows Madison Avenue (Union Street) on the west side. The buildings face east with a grain elevator at the foot of the street on the shore. The limestone building on the left is the Sawyer branch of the Bank of Sturgeon Bay.

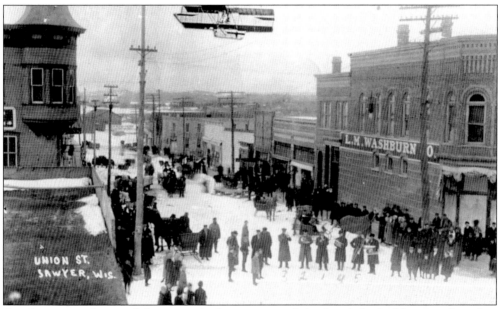

Another postcard view of the west side shows a street festival and the buildings on the other side of Madison Avenue (Union Street). The airplane is obviously fake, pasted onto the scene. It was a popular practice to add planes or streetcars to small town views during the early part of the 20th century.

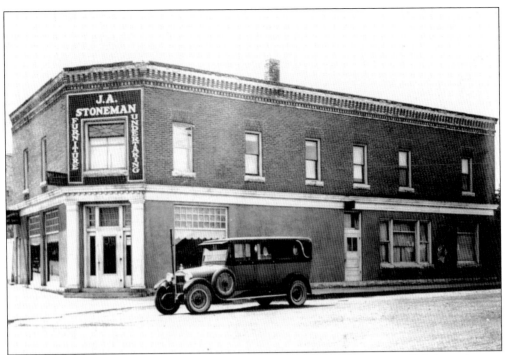

J. A. Stoneman's Quality Furniture and Funeral Home occupied one corner of Madison Avenue and Maple Street. The building, first built as the Raymond Hotel in 1890, became the Fortemps Hotel and Saloon from 1904 to 1916. Now the building houses the Clippers Mate Styling Salon. (Photograph courtesy of Forbes Funeral Home.)

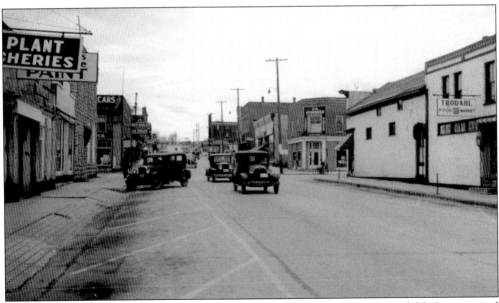

This view looks south on Madison Avenue. On the right is the old Trodahl Grocery and Stoneman's Funeral Home at the intersection of Madison Avenue and Maple Street.

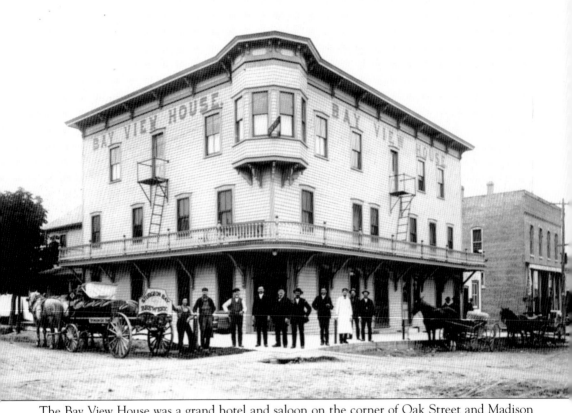

The Bay View House was a grand hotel and saloon on the corner of Oak Street and Madison Avenue on the present site of T. Simon Jeweler. John Goettelman (1843–1912) was the proprietor along with his wife, Phillipena (1851–1926). The horse-drawn wagon on the left is making a delivery from the Sturgeon Bay Brewery. In addition to the hotel business, John Goettelman helped establish his son, Henry, in the dry goods and grocery business down the street in the Goettelman Building, which still bears the Goettelman name. (Photograph courtesy of the Goettelman family.)

These two c. 1905 photographs show the Eagle Hotel on Oak Street in Sawyer. It had an advantageous location next to the railroad depot (on the left). The owner was Charles Hitt, who moved to town from Claybanks, where he had operated a hotel for the sawmill workers. The tavern, with an addition, operates today as The Stein. The depot became Culligan Water Conditioning. The men at the bar of the Eagle Hotel are, from left to right, bartender Ross Foxworthy, Ole Erland, Steve Nelson, Jack Moore (1881–1949), Les Hitt (1877–1955), and Joe Matashe. (Photographs courtesy of Dick Hitt.)

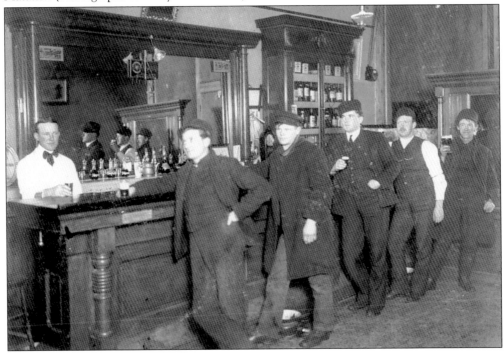

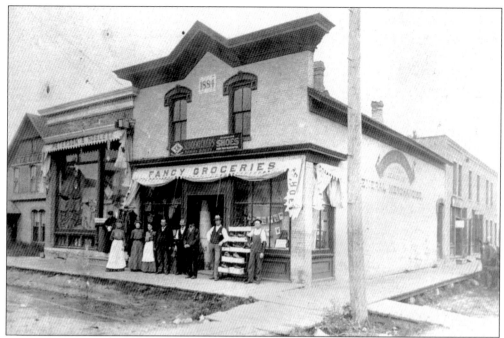

Herbert Peterson and Joseph Hostlett operated this grocery store that was built by Hostlett's father-in-law, E. N. Anderson, in 1870. This 1904 view shows the storefront at the Maple Street and Madison Avenue corner with intersecting boardwalks. Otis Trodahl began working at the store in 1917 and bought the business in 1933. He remodeled the building by turning it into a modern self-serve grocery in 1951, as shown below. The store building was razed in 1966, and the Hole-in-One gas station and convenience store sits on the site. In his retirement, Trodahl was the curator of the Door County Historical Museum from 1962 to 1979. He donated many items for use in the museum's old-time grocery display. (Original photography—lower photograph—by Herb Reynolds.)

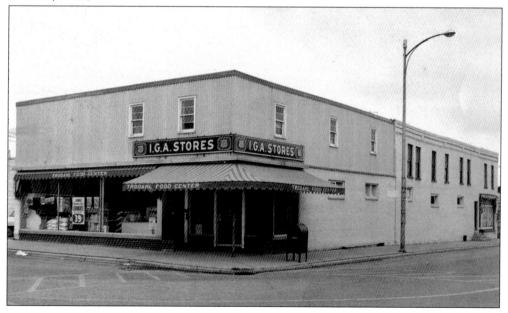

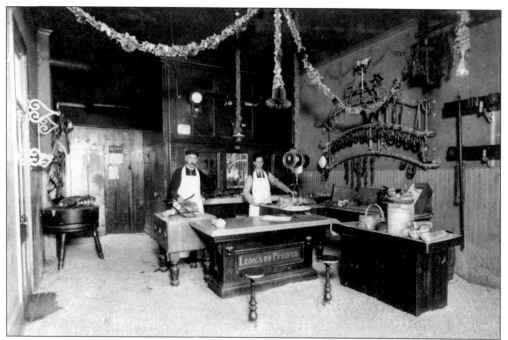

In 1908, Leonard Pfeifer operated this meat market at 58 West Maple Street in the same building that houses Abby's Monkey Business today. This typical arrangement for a meat market shows sawdust on the floor, sausages on the wall, and stools for customers to wait while an order was cut and packaged. By 1921, this same shop was operated by John and Mary Haen as shown below. The store had been remodeled to accommodate a few more groceries along with the fresh meat. During the early part of the 20th century, meat markets were abundant. Both the Pfeifer and Haen families operated markets on both sides of the bay.

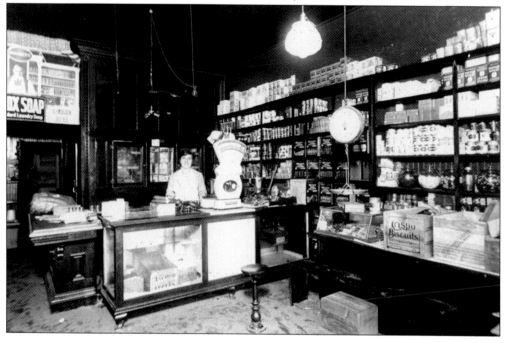

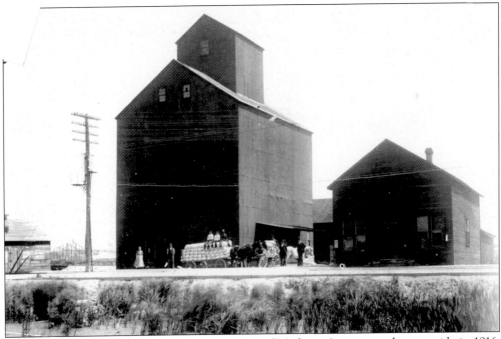

The Lyon Brothers grain elevator was at the foot of Madison Avenue on the west side in 1916. Here, workers pose along the shore with a wagonload of their product. The elevator burned down on July 5, 1960, while in use as the Peninsula Feed Store.

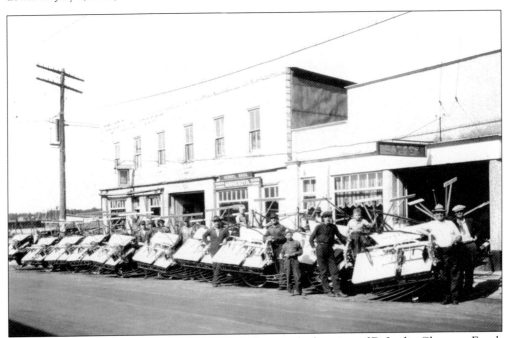

The Hembel Brothers Garage was on the west side, now the location of DeJardin Cleaners. Frank and William Hembel went into the farm implement business in 1904 selling steam tractors. They moved their operation into this building in 1931. In addition to farm machinery, they sold Reo, Graham, and Ford cars. (Photograph courtesy of Dan Austad.)

These gents are enjoying a pail of beer together at Louis Marx's harness shop in the 1940s. From left to right are Leonard Pfeifer, Louis Marx, Ellsworth Ellis, and Hans Halvorson. They met daily at Marx's shop on Neenah Avenue and Oak Street. Marx came to Door County in 1905 and continued in the harness business until 1950, when his shop was completely destroyed by fire. (Original photography by Roger Schroeder.)

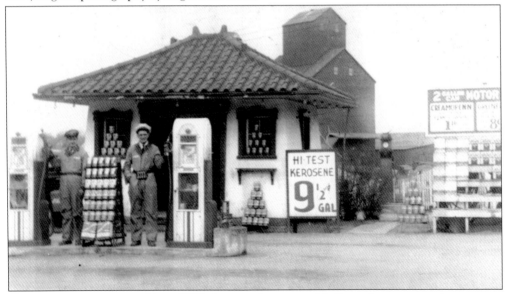

This gas station, seen in this c. 1940 photograph, was on Madison Avenue near the entrance to the bridge in the area of the Maritime Museum's parking lot. The gas station was owned by Peter Peterson and later by his son, Mason. This little building was moved in 1955 to make way for a new more modern station, which remained until 1990. (Photograph courtesy of Mike and Barb Chisholm.)

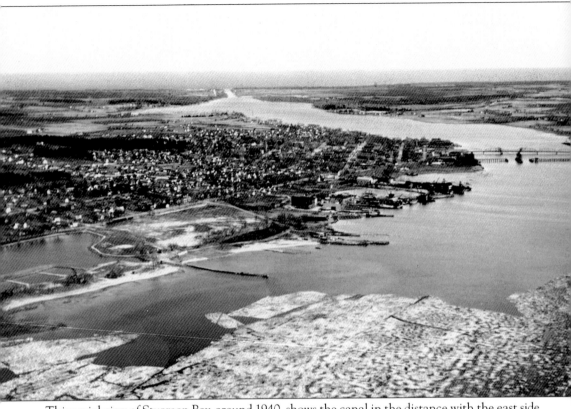

This aerial view of Sturgeon Bay, around 1940, shows the canal in the distance with the east side of the city in view. (Original photography by W. C. Schroeder.)

Four

PUBLIC SERVICE

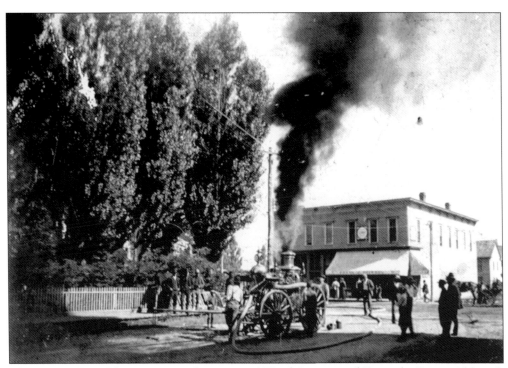

The steamer *Long John* is in use at the corner of Third Avenue and Kentucky Street. Although it was difficult to provide adequate fire protection before the days of motorized vehicles and pumps, the valiant firefighters worked hard to protect the citizens of Sturgeon Bay from the all too common devastation of fire. Sturgeon Bay had a city police department and was the headquarters of the sheriff's department and the county courthouse. The post office and later the phone company allowed folks to connect. The medical doctors and nurses kept the citizenry as healthy as the time would allow. (Photograph courtesy of Clyde Smith.)

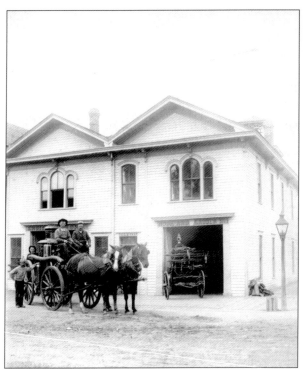

The firehouse for the city's volunteer Pioneer Fire Company, organized in 1869, was located on Fourth Avenue and Michigan Street on the site of the old library. The company's prized piece of equipment was a hand-operated fire wagon that projected a one-inch stream of water to the roof of a story and a half building. (Photograph courtesy of Clyde Smith.)

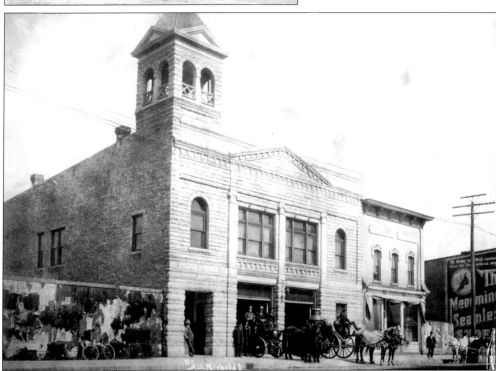

This Sturgeon Bay Firehouse was built in 1908 and continued in use until 2006, when a new fire station and city hall complex were built downtown. A second firehouse now operates on the west side.

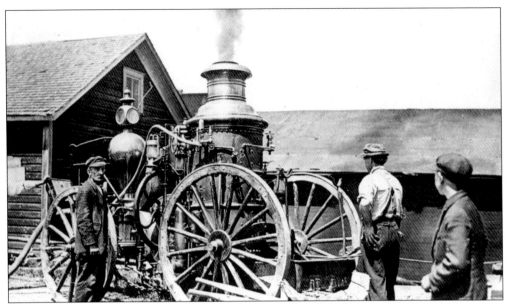

The steamer *Long John* was purchased in 1880 for Sturgeon Bay from the City of Chicago. It was named after Mayor "Long John" Wentworth and played a major role in the Great Chicago Fire. This unit was replaced by a 1920 Oldsmobile fire truck. It was scrapped in the 1940s for brass used in the war effort. Pictured from left to right are Wallace L. Ives, Almon Ives, and an unidentified boy.

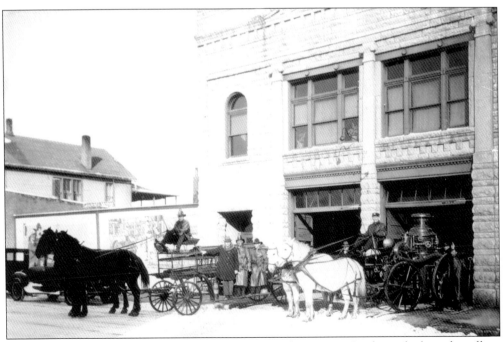

This was the last time the horses were hooked up to the steamer. In the early days, the village had no horses. So with the advent of the steam fire engine, an award of $5 to $10 was offered to the first team arriving at the engine house after the fire alarm had sounded. It produced some spectacular races, which added greatly to the general excitement of a fire

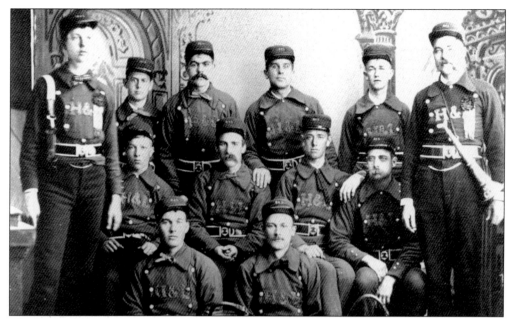

This hook and ladder company organized at the same time as the Pioneer Fire Company in 1869. Its members were not connected with the operation of the fire wagon devised and built for the Pioneer Fire Company. They disbanded by 1876 but reorganized after a fire destroyed a grain warehouse and icehouse, demonstrating the need for more fire protection. The village then supplied them with their own fire wagon.

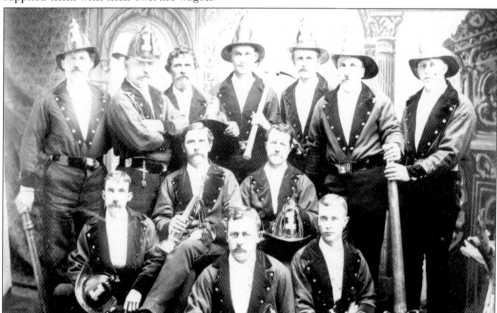

This is a photograph of the city's first paid fire department, organized under the supervision of a chief appointed by the mayor. It was organized after the volunteer Pioneer Company disbanded. From left to right are (first row) Chief W.M. Halstead and Frank Lawrence; (second row) Wallace Ives, H. M. McNalle, and Henry Leonhardt; (third row) Arnold Wagner, F. X. Sailer, John Rothman, Will Cochems, George Bradel, Will Lawrence, and Charles Lavassor.

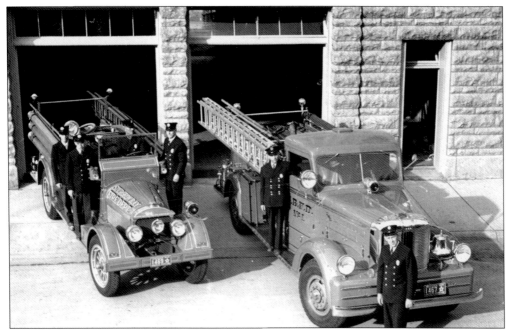

Firemen show off their fire trucks in front of the station around 1940. The 1926 Nott on the left and the 1938 FWD pumper are currently on display at the Door County Historical Museum, along with the department's original hand-drawn fire wagon and 1920 Oldsmobile. (Original photography by W. C. Schroeder.)

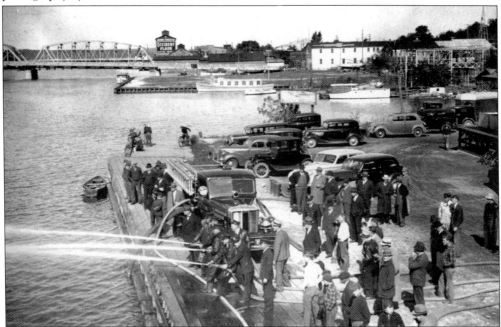

Firemen test their new 1938 truck by drawing water from the bay. The city purchased this highly efficient pumper from the FWD Corporation of Clintonville, Wisconsin. It was one of the few trucks made with a chrome grill and was the pride and joy of Sturgeon Bay aldermen, who took visitors to the station to show off the truck. (Original photography by W. C. Schroeder.)

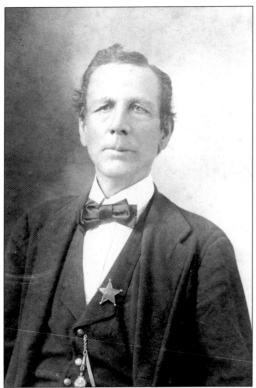

Horace Van Doozer (1832–1912) was born in New York and later settled with his parents in Algoma, Wisconsin. He served in the Civil War with the 43rd Wisconsin Volunteers before becoming constable in Algoma. He served as the Sturgeon Bay chief of police from 1901 to 1906. He was the oldest chief of police in the state when he retired at the age of 73.

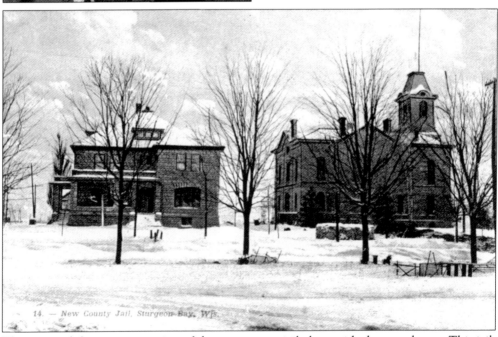

14. — New County Jail, Sturgeon Bay, Wis.

This postcard shows a winter view of the new county jail along with the courthouse. This jail, known as the Greystone Hotel, was in use from 1909 to 1965. It sat on the corner of Fifth Avenue and Nebraska Street. The sheriff and his family also lived in the building. It was replaced with a new Safety Building on the same site.

Chief of Police Romain "Romie" Londo (1904–1969) had a legendary 37-year-long career with the Sturgeon Bay Police Department. One of three policemen when he started in 1930, he was assigned to walk a beat on both the east and west sides. Once a semi-professional wrestler, Londo had a reputation that few of the town toughs cared to challenge. Many still remember him, as chief, directing traffic in the downtown intersections on busy, hot summer days.

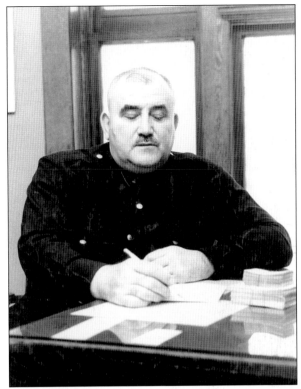

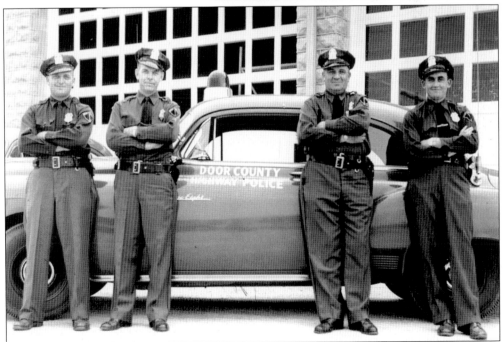

In 1952, the Door County Highway Police posed with their vehicle in front of the Highway Shop on Fourteenth Avenue. The officers are, from left to right, Maurice "Muzz" Millard, Eldon Carmody, Joseph Antonissen, and Dan O'Hern.

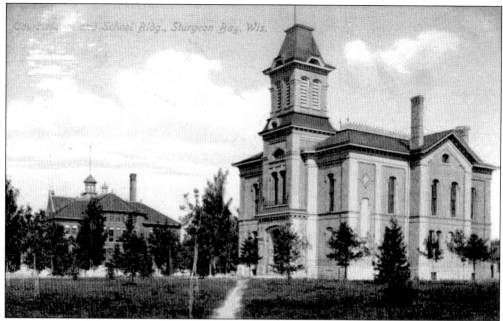

This postcard shows the Door County Courthouse with the high school to the left. The courthouse, built in 1878, stood facing Fourth Avenue on the same site as the succeeding courthouse. Portions of this building remained until 1991, when the last section was torn down to make way for an addition to the modern building. The school burned down in 1908.

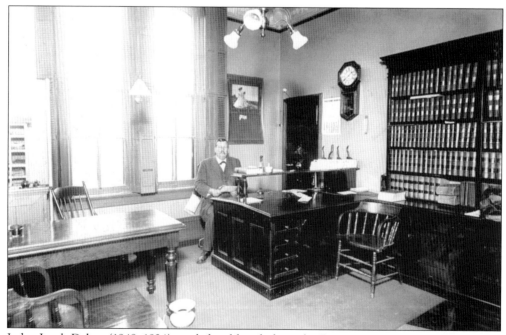

Judge Jacob Dehos (1848–1934) sits behind his desk in the Door County Courthouse, around 1920. Born in Germany, Dehos came to the United States at the age of 16. He had a boot and shoe shop on the site of city hall on Third Avenue. He was a justice of the peace for 26 years and county judge from 1902 to 1932. He was the oldest judge in Wisconsin.

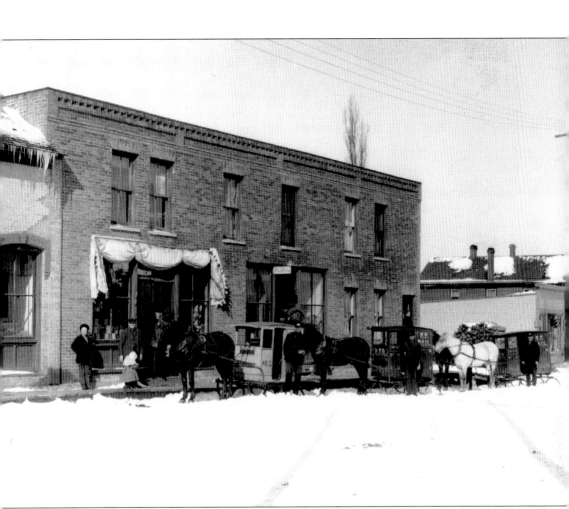

The Sawyer rural carriers line up outside of the post office in 1916. This building was located on Union Street (now Madison Avenue). Sawyer, the west side of Sturgeon Bay, was originally platted in 1872 and named Bay View by Joseph Harris Sr. According to James Hale in his book *Going for the Mail*, "He [Joseph Harris Sr.] wanted to provide facilities for the population boom anticipated when work started on the canal. He was unable to get approval of Bay View as the name for a new post office, since there was already an office of that name in Milwaukee County, so he had the office named in honor of Congressman Philetus Sawyer of Oshkosh, Wisconsin. Congressman Sawyer, alleged to have been unable to read and write, employed Mr. Harris as his secretary when congress was in session and was one of the strong supporters of the canal project." The area soon became widely known as Sawyer, which continued even after it was annexed into the City of Sturgeon Bay in 1894.

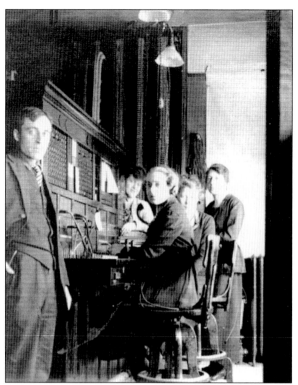

These women and gentleman are in the Sturgeon Bay Telephone office. Although the date of this photograph is unknown, in 1908 the office moved into the Pinney Building on the corner of Third Avenue and Michigan Street. They had a new switchboard with six operators: two local, two rural, and two long-distance.

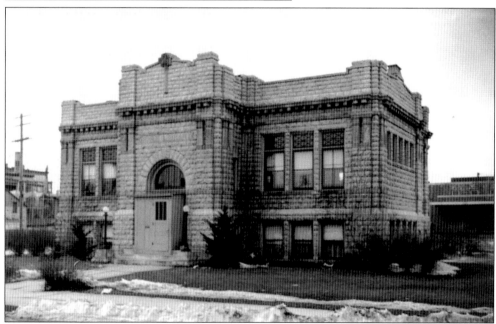

The old library at Fourth Avenue and Michigan Street was dedicated in 1913 after the city was granted $12,500 from Andrew Carnegie. The donation helped fulfill a dream of the earliest settlers when they formed a library association in 1866. Thousands of books were collected before the opening. The library was considered to be one of the most architecturally beautiful in the state. (Original photography by W. C. Schroeder.)

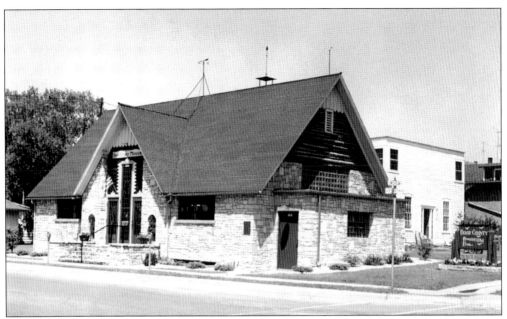

The Door County Historical Museum was dedicated in 1939 after many years of effort by the Door County Historical Society, Harry Dankoler, and members of the city and county government. Much of the construction on the Scandinavian-style building was achieved through a grant from the Works Progress Administration (WPA). The Pivonka Monument Works occupied the lot behind the museum where the 1984 addition now stands.

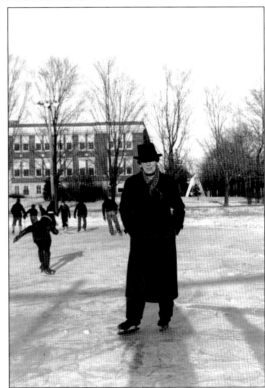

Harry Dankoler (1864–1955), known as "Uncle Harry," loved to ice skate. Here he is at Market Square, around 80 years old. He believed he could ward off illness with a few brisk laps around the rink. Dankoler dedicated the last third of his long life to the museum. As the first curator, he was involved in all aspects of its development, from construction of the building to collecting and displaying the artifacts.

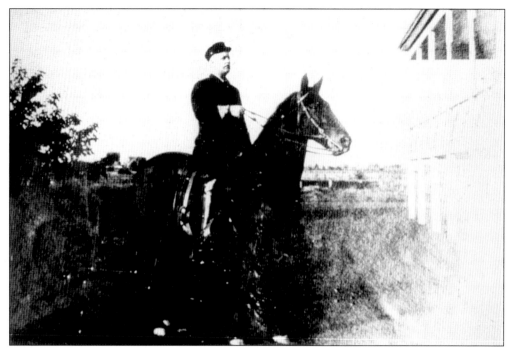

Dr. Henry Cheever Sibree (1852–1923) graduated from Northwestern University in 1878 and came to Sturgeon Bay in 1883. He claimed to be the first doctor to operate for appendicitis in Door County. At a time when most patients were seen at home, he traveled on his horse, Midnight, to make his calls.

As a result of the 1901–1902 small pox and "Cuban Itch" epidemics, which struck the county full force, Dr. Sibree erected the county's first hospital that winter, naming it the Bay Shore Hospital and Sanitarium, and later the People's Hospital. It was located at 818 South Cedar Street (now Memorial Drive). The hospital was abandoned and torn down after Sibree died.

Dr. Gustave R. Egeland (1876–1936) was born in Sturgeon Bay, the son of a pioneer tug man from Norway. After medical school, he practiced with Dr. Sibree and in Ephraim. In 1914, Egeland started his own hospital in Sturgeon Bay. He served with the Medical Officer Reserve Corps in World War I and later practiced with his nephew, Dr. Dan Dorchester. (Photograph courtesy of Janet Nicholson.)

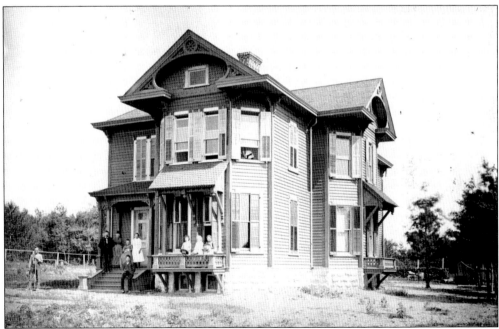

This home, at 519 Garland Street (now Jefferson Street), was built by Frank Long, editor of *The Door County Advocate* from 1875 to his death in 1912. Dr. Egeland bought the home and converted it to Egeland Hospital. After it burned, he rebuilt the hospital on the same site and continued to practice along with Dr. Dorchester.

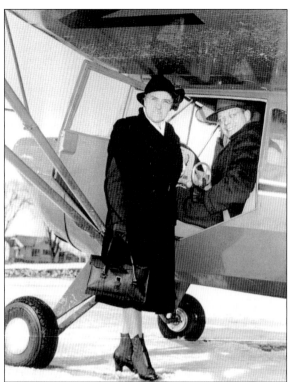

Dr. Daniel Dorchester (1905–1966), known as the flying doctor, and his nurse, Ruth Brey, pose with the plane he would pilot to treat patients on Washington Island. "Dr. Dan" was instrumental in the formation of the Cherryland Airport and established a clinic for the migrant workers during the cherry harvest. He had a policy that all babies born on his birthday, September 22, were free! (Photograph courtesy of W. C. Schroeder.)

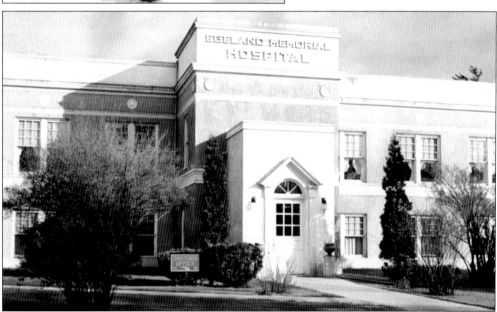

After Dr. Egeland died, Dr. Dorchester continued running his hospital, renamed the Egeland Memorial Hospital. During the boom years of World War II, Dorchester recognized that the hospital needed to increase its capacity. He successfully lobbied in Washington, D.C., for funds to build an addition. He then turned the hospital over to the non-profit Door County Memorial Hospital Corporation. After a new hospital was built in 1963, this building became the Dorchester Health Center.

Five

FAMILY LIFE AND RECREATION

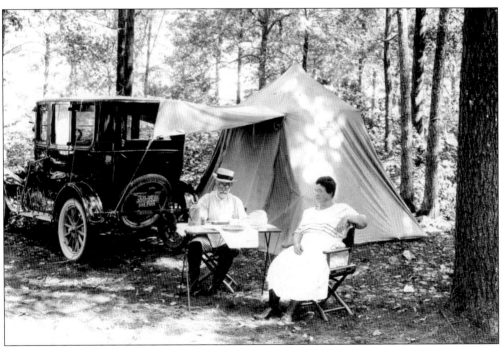

This couple relaxes at their campsite in a woods near Sturgeon Bay in 1923. Abundant natural beauty encompasses Sturgeon Bay's land and water. It has always been a backdrop to family life. As homes, good schools, and a variety of churches were built, the inhabitants took time to ensure that their families flourished in both body and spirit. No matter what the season, the people of Sturgeon Bay could be found outdoors, fishing, swimming, skating, or playing in a hearty cover of new snow.

Nelson R. Lee, a Civil War veteran, built this house in 1867 on the site of the first cemetery in Sturgeon Bay at Second Avenue and Louisiana Street. It is now the Corner House, one of the houses of the Barbican Guest House. (Photograph courtesy of Jim Pichette.)

Bert and Augusta Scofield built this house at 908 Michigan Street in 1902. Following in his fathers footsteps, Bert was an early mayor as well as the first president of the chamber of commerce. He owned a hardware business that was in operation for well over 50 years. This house was renovated into a bed-and-breakfast in 1987.

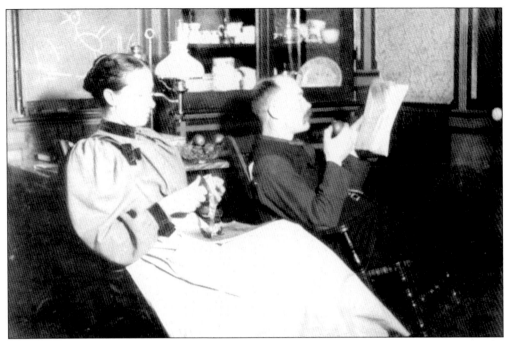

Bert and "Gussie" Scofield are relaxing and enjoying apples in their home. Notice the chalkboard with the stick bird figure. Bert enjoyed drawing and would adorn his letters with these trademark figures.

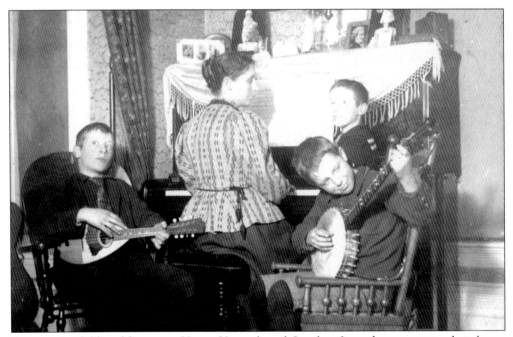

Augusta Scofield and her sons, Harry, Howard, and Stanley, formed a quartet in their home in 1897. Augusta was a former teacher who met her husband when they both worked at the A. W. Lawrence General Store. She took an active interest in the business and traveled to many hardware conventions.

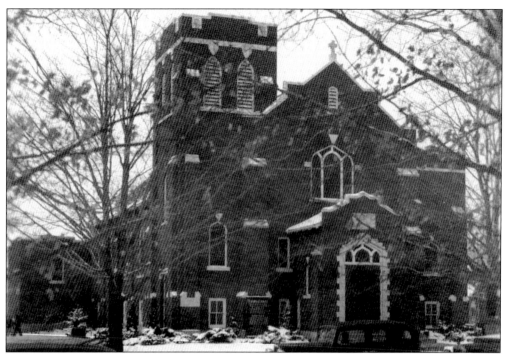

The Moravian Church, shown around 1940, is located on South Fifth Avenue. Rev. A. M. Iverson founded the Moravian settlement in Ephraim in 1853 and shortly afterward came to Sturgeon Bay to assist another new congregation. It was formally organized in 1864. The Moravians built a new church in 1880 and the present church in 1934. (Original photography by W. C. Schroeder.)

St. Peter's Lutheran Church on Maple Avenue on the west side was historically known as the German Lutheran Church. This frame building was constructed in 1891, the same year the congregation was organized. Nearby was the Bayview Lutheran Church, historically known as the Norwegian Lutheran Church.

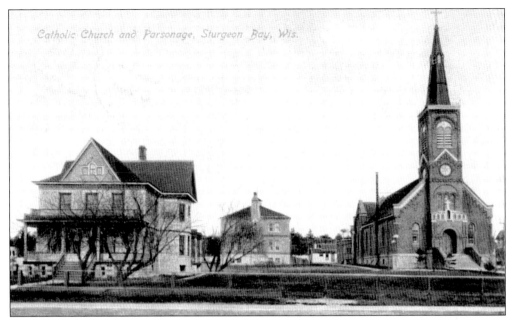

By 1865, Catholic settlers recognized the need for a mission parish at Sturgeon Bay. They bought a four-acre tract of land from J. Lavassor for $66 and erected a small frame building on North Fifth Avenue. Shown is the first brick church completed in 1891. Within a few years, a larger safer building was needed for the growing congregation. The new, and current, twin steeple church was completed in 1910.

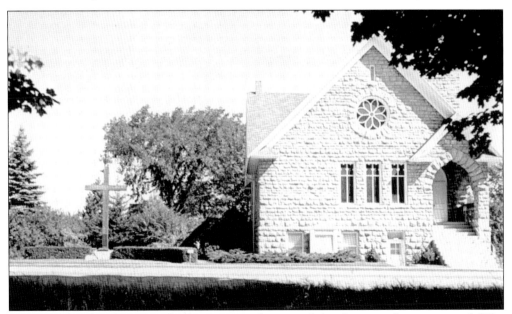

The Friends Church on Maple Avenue was the site of the first complete singing of "The Old Rugged Cross" on January 12, 1913. Rev. George Bennard, visiting for a series of revival meetings, wrote and then performed the piece accompanied by 13-year-old church member Pearl Torstenson. The hymn has become a favorite of Christians throughout the world. (Photograph courtesy of Richard Lauder.)

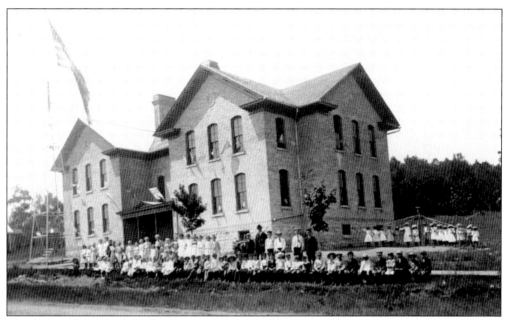

This Sawyer School was built as a two-story brick structure in 1888 and was enlarged in 1913. It was located on Neenah Street near the current Bayview Terrace Apartments. The photograph was probably taken on May Day with the girls posed around the maypole.

Girls from St. Joseph's Holy Guardian Angel School put on a play. They are gathered on Louisiana Street on what is now the St. Joseph rectory front lawn. From left to right are Mildred (Writt) Conlon, Frances Bourgeous, Mercedes (Moeller) Haen, Dorothy (Propsom) Peichel, Mary (Haen) Holstein, Mildred (Simon) Stone, Mary (Pivonka) Schaefer, Agnes LaPlant, Mildred Toseland, Bernice (Writt) DeBauche, Dorothy (Hartel) Radtke, Kathryn Egan, Margaret (Haen) Beadel, and Catherine (Acker) Navarre. (Photograph courtesy of Ginny Haen.)

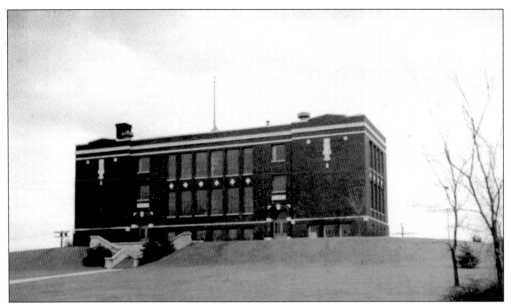

The West Side School on the top of the hill on Madison Avenue and Pine Street was in use from 1921 to 1997. A group of west side businessmen fought to have this beautiful building with an expansive view of the city for the "Sawyer Side." They also wanted it to include a high school. It housed kindergarten through 10th grade in the early years but later became solely an elementary school.

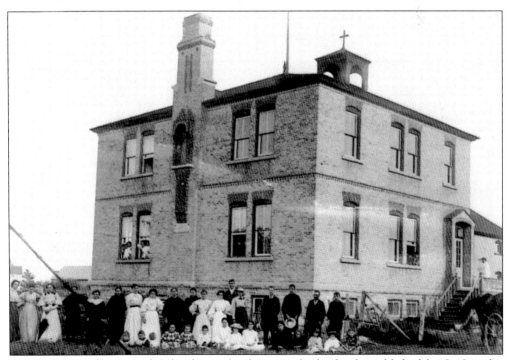

The Holy Guardian Angel School was the first parochial school established by St. Joseph's parish on North Fifth Avenue. The brick building was dedicated on October 3, 1888. It opened with 111 students. (Photograph courtesy of Barb Chisholm.)

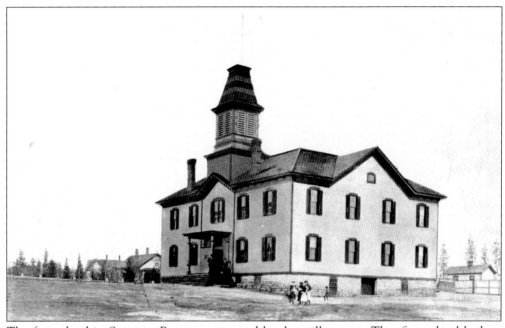

The first school in Sturgeon Bay was supported by the mill owners. That first school had no desks, only benches. After it burned down, school classes were held at various businesses and residences around the city. Finally, in 1870, the public school, shown above, was erected on the northwest corner of Fifth Avenue and Michigan Street. In 1901, a new brick school, shown below, was built across the street where the fire station and city hall, built in 2006, now sits. The frame school was later torn down.

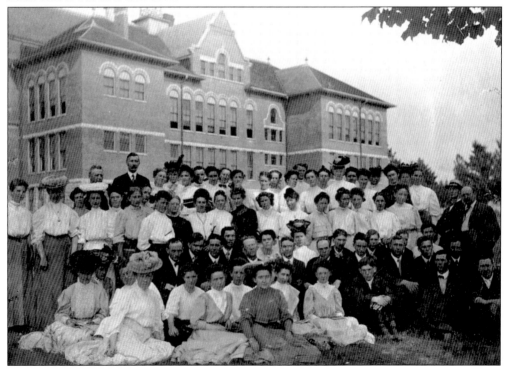

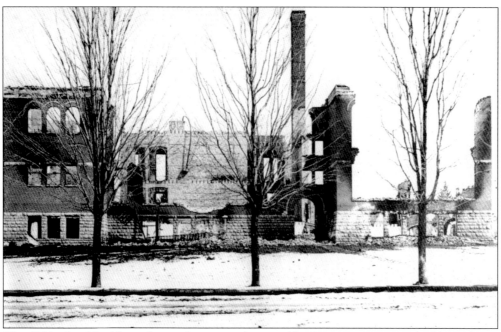

The 1901 school building, shown above, was destroyed by fire in 1908. A new building, shown below, was opened in 1909 on the same site. This building served students of all ages until 1954, when the Sunrise and Sunset Elementary Schools opened alleviating some crowding. The new high school and middle school were built in 1969 and 1980, respectively, on the outskirts of the city, ending 100 years of schools in the downtown.

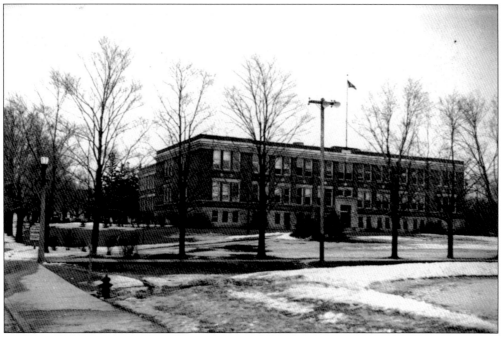

Eddie Cochems (1877–1953) was an athlete from Sturgeon Bay who went on to a successful college football coaching career. In 1906, Cochems, as coach of the St. Louis University Billikens, led his team to victory by using an extensive passing game. This has earned him a place in the sports history books as the "Father of the Forward Pass."

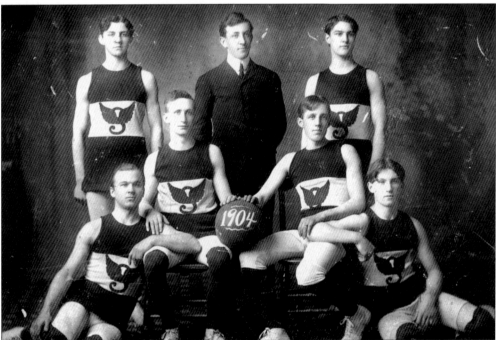

In 1904, Sturgeon Bay High School formed its first basketball team, shown here. From left to right are (first row) H. O. Bernhardt, Clarence Lavassor, Sam VanDoozer, and John McNerney; (second row) Frank Graass, administrator Rudolph Soukup, and Walter Wagener.

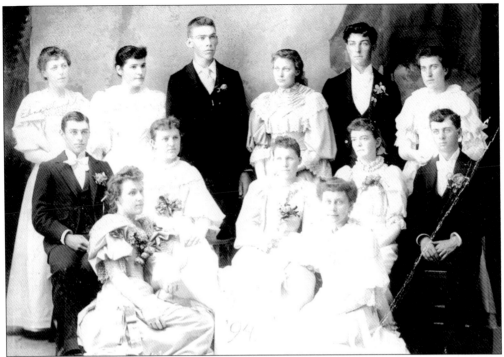

The graduates of the class of 1894 are dressed in their finery. From left to right are (first row) Mabel Harris and Marie Backey; (second row) William McEachem, Mame Calignon, Belle Hamilton, Myra Parkman, and George Nelson; (third row) Edna Thorp, Nellie Devine, Louis Carlson, Jessie Nelson, Henry Graass, and Eva Dehos.

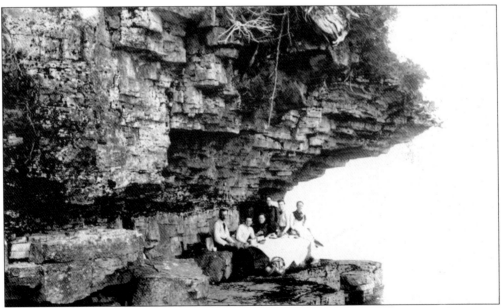

Lover's Leap near Sherwood Point at the mouth of Sturgeon Bay was once a very popular spot to picnic and rest in the cool shade under the overhanging rock. The rock collapsed on June 21, 1912, just hours after a high school class spent an afternoon playing on and under Lover's Leap.

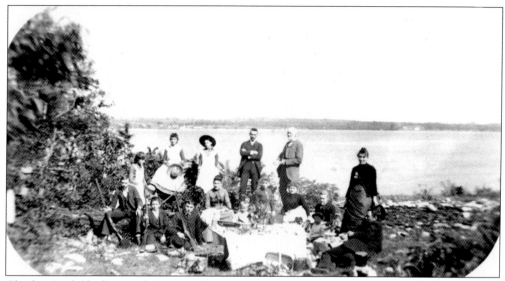

Charles Scofield, the gray-haired gentleman in the back, poses at a picnic with his extended family near the Washington Ice Company in September of 1888. The boys have their rifles ready to hunt.

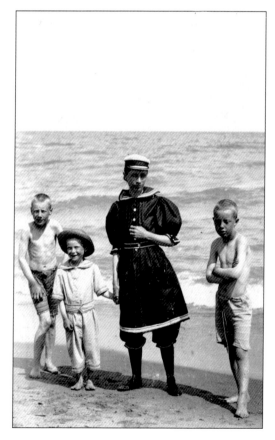

Augusta Scofield stands on the beach of Lake Michigan with her sons, Harry, Stanley, and Howard, around 1895. The family kept a small cottage at the lake for retreat from the bustle of Sturgeon Bay. Her elaborate bathing costume was the height of fashion.

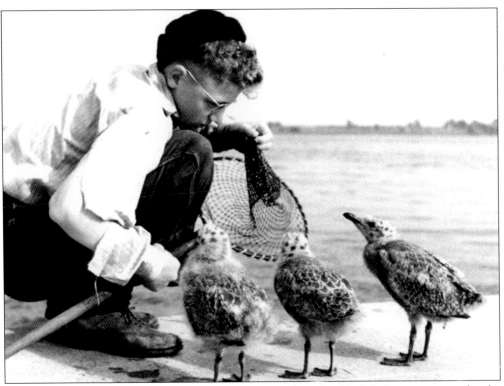

These baby seagulls were being cared for by Roger Schroeder. He fed them minnows that he caught with a dip net at the dock. (Original photography by W. C. Schroeder.)

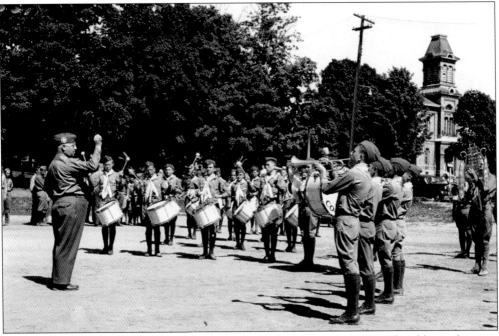

A visiting drum and bugle corps performs at Market Square around 1939. The old courthouse is in the background. (Original photography by W. C. Schroeder.)

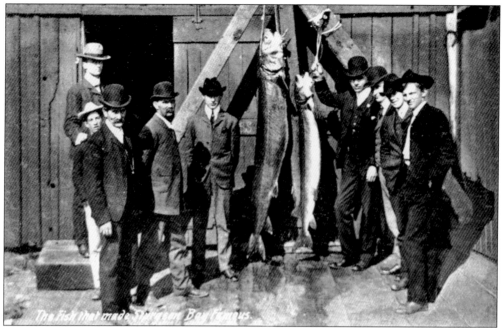

This big sturgeon picture from 1902 was widely circulated on postcards and dishes. The large sturgeon was 173 pounds and the smaller 68 pounds. Once plentiful in Sturgeon Bay, the species was fished so extensively that their populations were reduced to a level from which they have never recovered. Adding to the problem, damming of streams for power generation has greatly diminished the lake sturgeon's spawning grounds.

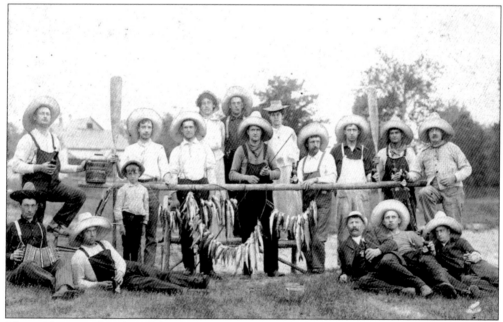

These fishermen, friends and family of Joseph Schlise, gathered around the day's catch of perch, northern pike, small mouth bass, and walleye while enjoying bottles of beer. (Photograph courtesy of Frank Tachovsky.)

Andy Foeller and Roger Schroeder are fishing for perch at the canal. The dock was in a small inlet where the fish boats tied up. (Original photography by W. C. Schroeder.)

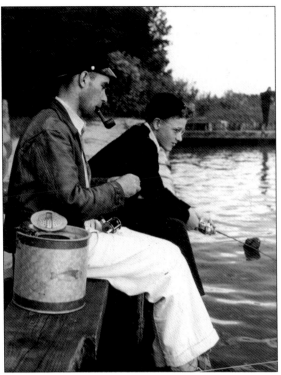

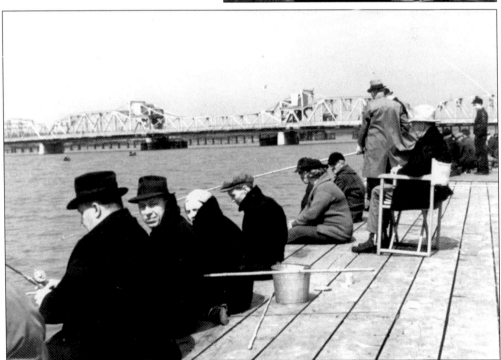

The Goodrich Dock, where the cruise ships landed, was a favorite fishing spot during the depression. One dip net would yield all the minnows needed for a day's fishing. (Original photography by W. C. Schroeder.)

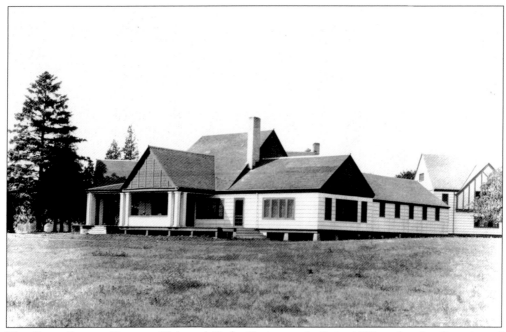

The Door County Country Club and Yacht Basin was built in 1923 under the direction of Leathem Smith and eight other partners. Smith bought out the others in 1929 and renamed the place the Commodore Club. His intention was to create a sportsmen's club that would include extensive hunting grounds as well as the golf course. The club was reopened as Leathem Smith Lodge in 1946, the same weekend that Leathem Smith died in a terrible boating accident. Shown are the original lodge and golfers on the nine-hole course. The course was located adjacent to the lodge along the Sturgeon Bay shore in the area now developed as Highway 42/57 and the Snug Harbor Estates.

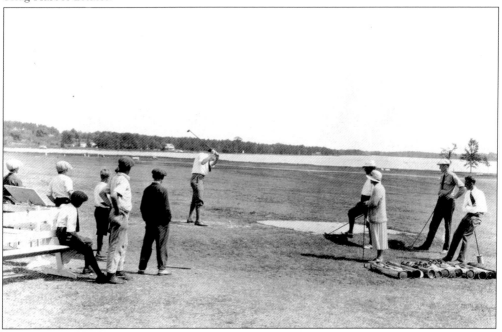

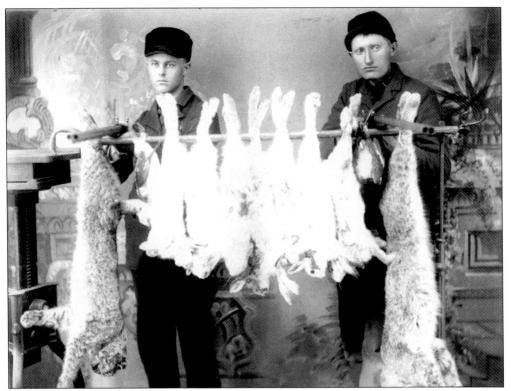

This is the bounty from one day's hunt on March 18, 1893. Raymond Bavry, left, (1875–1945) and his friend Jule Collard (1862–1924) shot two wild cats, two ducks, and seven snowshoe rabbits. All were shot north of the canal. Interestingly, the photograph was taken in a studio.

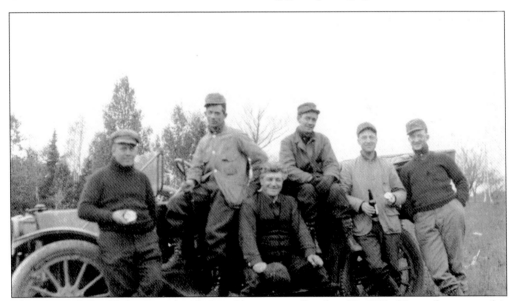

The Hasenpfeffer Club takes a break from hunting on October 28, 1913. Given the name, this was most likely a rabbit hunting expedition. The club members, from left to right, are Joe Schauer, Earl "Mitch" LaPlant, Henry Graass, James Spalsbury, William Wagner, and Clark Bassett.

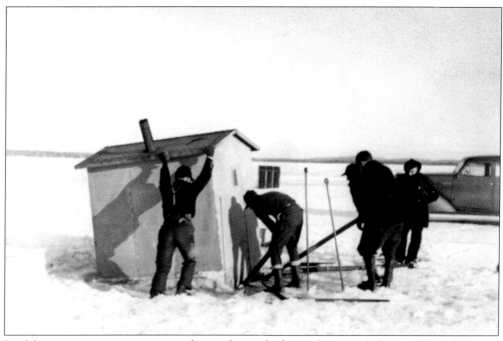

Ice fishermen are trying to rescue a shanty that melted into the ice in February 1939. They were at the north end of Sturgeon Bay off Pottawatomi Park. In those days, there was no bag limit on perch, and it was not unusual to come home with many fish meals. (Original photography by W. C. Schroeder.)

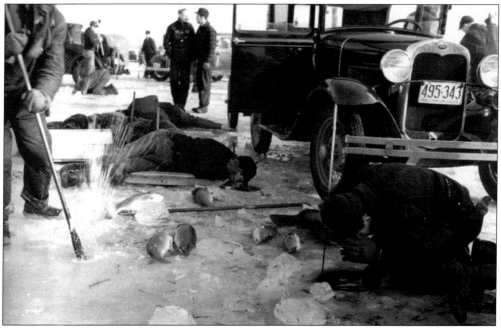

This group is looking for carp through holes in the ice. During the Depression, they would catch the carp on gaff hooks and sell them in Chicago at the open air market on Maxwell Street. (Original photography by W. C. Schroeder.)

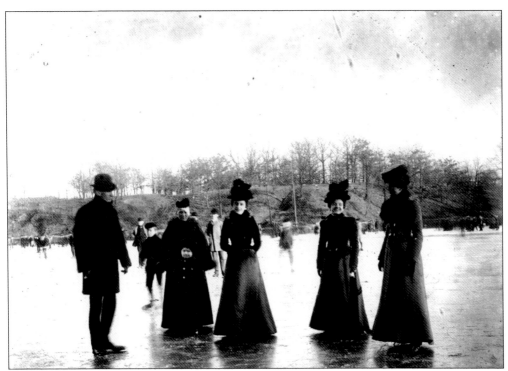

Museum founder, Harry Dankoler, titled this photograph, "Syl, Grandma and others on skates, Sturgeon Bay 1900." Harry enjoyed photography and attempted to record every day of his son Sylvester's life. Sadly, his wife and Sylvester both died in 1908. (Photograph courtesy of the Wisconsin Historical Society—Image ID No. 33923.)

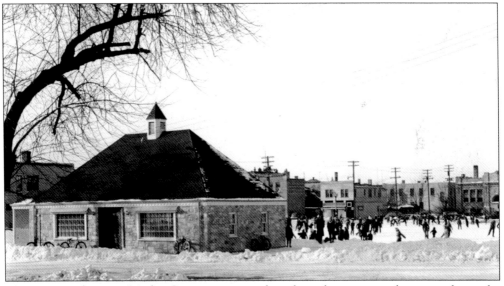

This warming house at Market Square was new when these skaters enjoyed a winter day in the late 1930s. In those days, the base was a sandy surface, which held the ice well. A loudspeaker played music of the day as crowds of skaters appeared day and night during the cold months. (Original photography by W. C. Schroeder.)

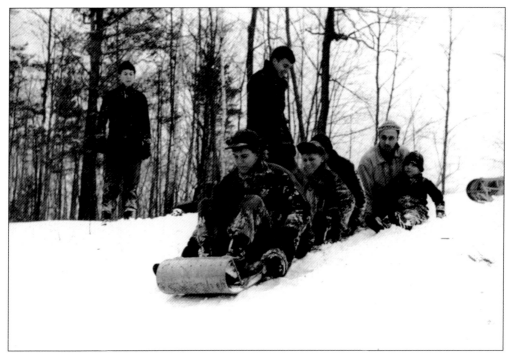

Gerhard Miller's Sunday school class from the Moravian Church went for a Sunday afternoon outing at the state park. Standing are Charles Bassford (left) and Clyde Stevenson. On the toboggan from front to back are John Goserud, Roger Schroeder, Daryl Paschke, and Gerhard Miller with his son, David. (Original photography by W. C. Schroeder.)

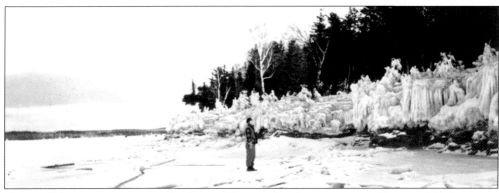

Cecelia Schroeder admires the ice formed from early winter storms at Sherwood Point at the mouth of Sturgeon Bay around 1944. (Original photography by W. C. Schroeder.)

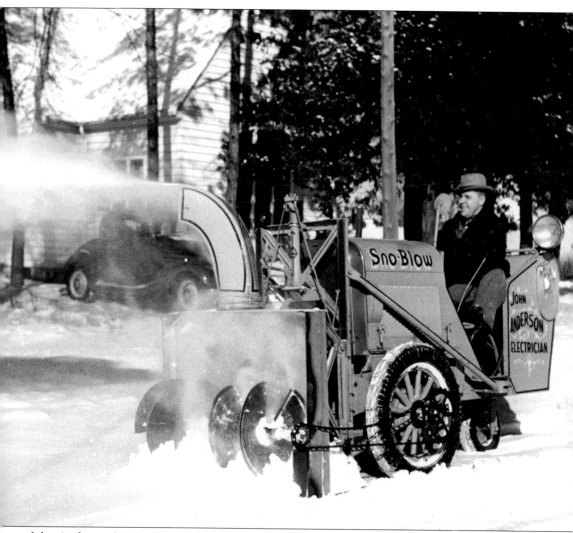

John Anderson (1911–1997) invented a full sized rotary sidewalk snowplow that he called the Sno Blow, shown here in 1939. He is best known in the area as the inventor of the Handi-Strap, an electrical cable fastener. He held six patents, exhibited at the New York World's Fair, and started the company Sturgeon Bay Metal Products. (Original photography by W. C. Schroeder.)

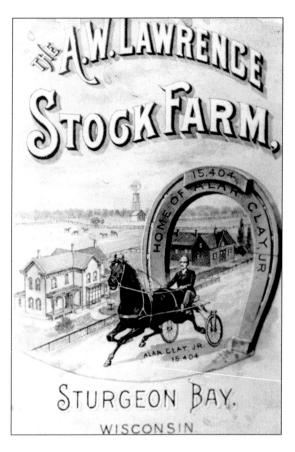

This poster for the A. W. Lawrence (1875–1939) horse farm promoted the popular sport of harness racing. The standard bred horses were either trotters or pacers. The horse pulling a driver in a cart called a sulky raced a mile race along a half-mile track. Harness racing continued at the fair until 1992.

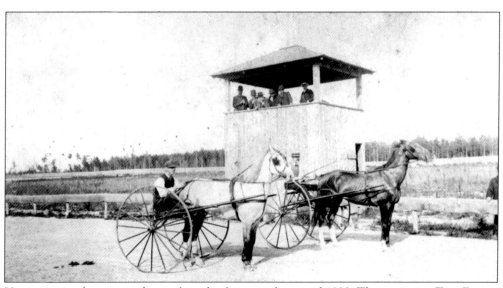

Harness racers line up on the track at the fairgrounds around 1890. The racers are Tom Franey (left) with "Grey George" and John Daley with "Buckskin." Officials watch from the stand. In the early days, the fairgrounds and horse track were off of North Eighth Avenue.

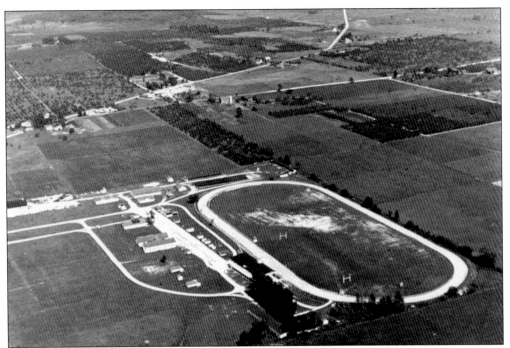

Here is an aerial view of the fairgrounds looking northeast in the 1940s. The high school played football inside the track before Memorial Field was developed. (Original photography by W. C. Schroeder.)

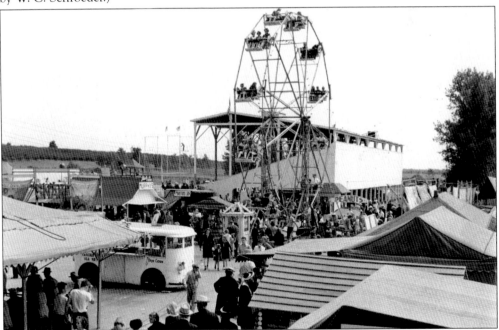

The first Door County Fair was held in 1869. It was usually in late August and marked the end of summer. In this c. 1940 photograph, you can see the midway with the old wooden grandstand that served the county for many years. A new grandstand was built in 1998. (Original photography by W. C. Schroeder.)

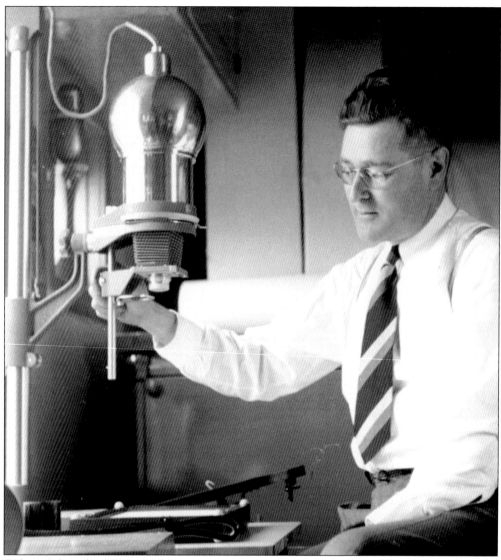

Wilmer Schroeder (1898–1946), an insurance man, was a self-taught prolific photographer who chronicled many aspects of Sturgeon Bay life during the 1930s and 1940s. He stands before his new Kodak Precision enlarger. He was a professional marine photographer during World War II, and thousands of his images remain as a testament to his craft.

Six

TOURISM BEGINNINGS

This postcard from Sturgeon Bay typifies a souvenir from a tourist destination. With its rail service and dock for cruise ships, the city and surrounding area became home to resorts and hotels serving the leisure class as well as business travelers marketing their wares in the burgeoning county seat.

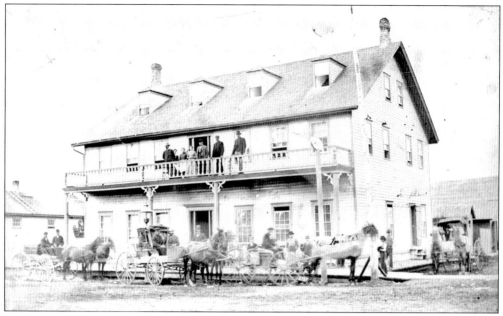

Northwestern House stood at the corner of Third Avenue and Louisiana Street on the site now occupied by Associated Bank. It was built by David Houle in 1869 and was purchased in 1870 by Henry Hahn Sr. This photograph, taken in 1877, shows Hahn in the buckboard to the right. A traveling man, with his trunk, is just coming or going. The hotel burned down on July 12, 1893.

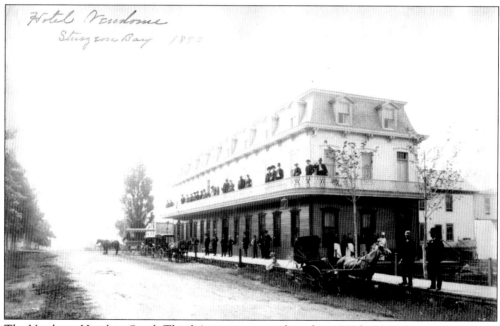

The Vendome Hotel on South Third Avenue was purchased in 1888 by V. T. Cromwell. Visitors only had a short walk to their lodgings from where the Goodrich Line and Hart Line ships docked. The Vendome Hotel burned down in 1899. The site was known as Vendome Park until 1922, when it was renamed after Mayor Frank Martin.

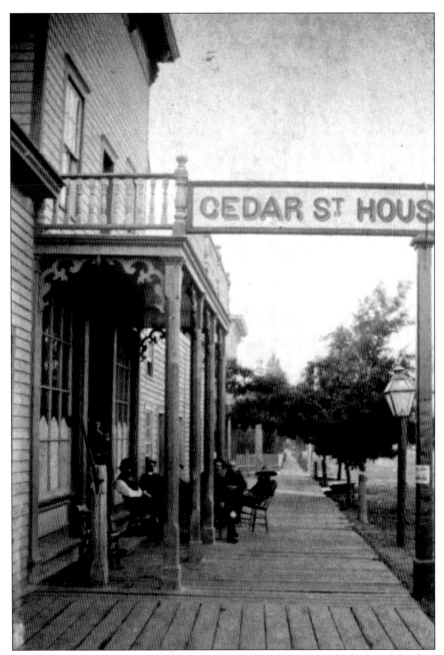

The Cedar Street House was near the present-day Hallmark Store in the heart of the downtown. It was the only hotel in the area when it opened in 1858, and the only building on that block. With numerous additions to it over the years, it had a saloon, a billiard hall, and a stable. The hotel even served as the site of the first major medical operation when a visiting doctor performed a double amputation on ferry owner Robert Noble, after his legs froze in a boating accident. Although considered a fine enough hostelry in its early days, in later years, the unregistered guests (rodents and bed bugs) dimmed its reputation. When it burned to the ground in 1886, the Cedar Street House was the oldest hotel in the county and was well known throughout the region.

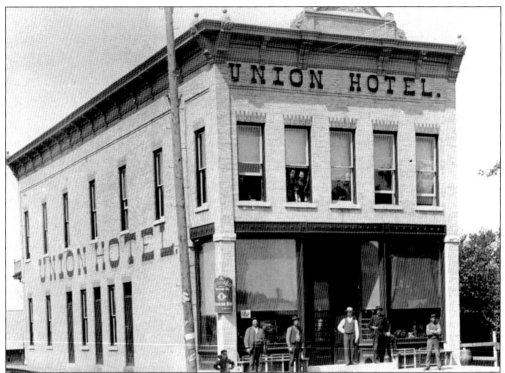

The Union Hotel, built in 1894 by Marcus Moeller, was located on the corner of Third Avenue and Jefferson Street. It offered spacious accommodations, including a dining room, sample rooms, lavatories on each floor, and a general bathroom. The hotel boasted of rooms with "pure and invigorating air with all the impurities strained out." In 1926, it was renamed The Carmen Hotel.

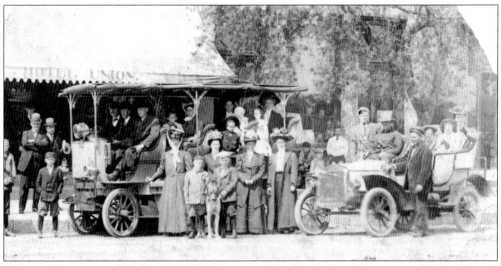

A bus and an automobile from Moeller's Livery, with a load of travelers, are parked in front of the Union Hotel. In connection with the hotel, the first-class livery service made connections with all the trains and boats, providing free transportation to all who stayed there. (Photograph courtesy of the Door County Archives.)

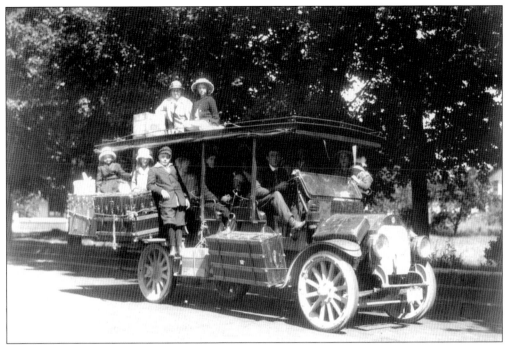

Ready for a holiday, these travelers have their trunks and suitcases strapped to the sides and hood of the bus. The Door County Northern Stage Line, with proprietors Alonzo S. Putman and Walter C. Olson, operated between 1915 and 1922. This autobus made connections with the railroad and boat lines at Sturgeon Bay for the villages of Egg Harbor, Fish Creek, Ephraim, Sister Bay, and Ellison Bay.

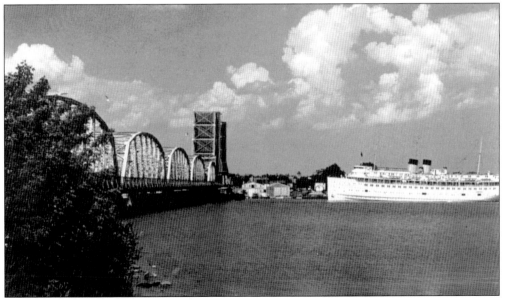

The *North American* cruise ship approaches the bridge around 1940. The Chicago, Duluth and Georgian Bay Transit Company operated luxury cruise ships on the Great Lakes between 1910 and 1960. The *North American* and its sister ship, the *South American*, held as many as 525 passengers and a crew of 150.

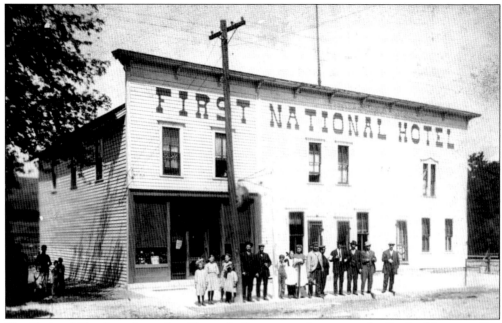

The National Hotel was located on Kentucky Street near the present day Bank of Sturgeon Bay drive-thru. The proprietor, Joseph Schlise, and his wife, Maggie, bought the hotel from John Leathem, the pioneer sawmill operator, around 1900. The National had a first-floor dining hall and a bar. Upstairs it featured small rooms for rent with a common bathroom. (Photograph courtesy of Frank Tachovsky.)

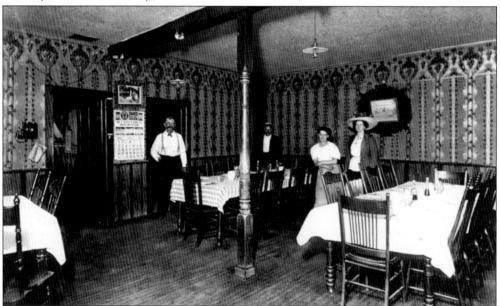

Here is the interior of the National Hotel's dining room in 1911. The Schlise's daughter, Margaret, a natural to the hotel business, quit school at eighth grade and worked in the business, including collecting rents from the tenants, many whom were sawmill workers. In 1918, her parents sold the hotel to Margaret and her new husband Ralph "George" DesEnfants. (Photograph courtesy of Frank Tachovsky.)

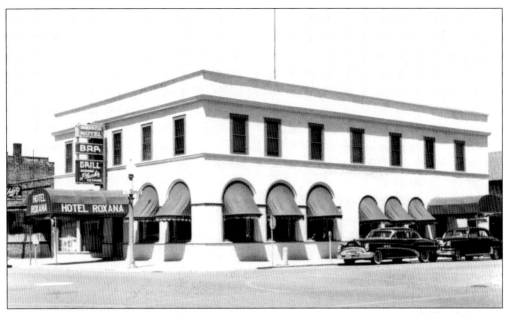

The DesEnfants bought the old Shimmel Grocery in 1928 on the corner of Third Avenue and Kentucky Street and completely remodeled it to unveil the Hotel Roxana, named after their daughter. During Prohibition, there was a speak-easy called the Snake Pit located in the basement. After it burned down, Baylake Bank developed a courtyard and clock tower on the site. (Photograph courtesy of Frank Tachovsky.)

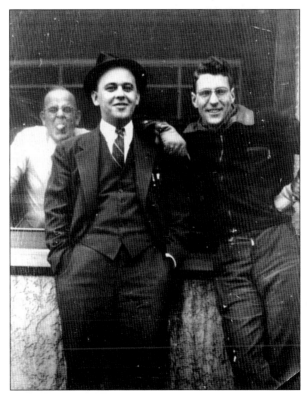

Here owner Ralph "George" DesEnfants has fun with the camera from behind a window at the Hotel Roxana along with customers Gene Bernhardt and Ken Wiest. DesEnfants, known as a somewhat rough character and jokester, joined the navy at the age of 17 and sailed around the world with Teddy Roosevelt's "White Fleet." (Photograph courtesy of Frank Tachovsky.)

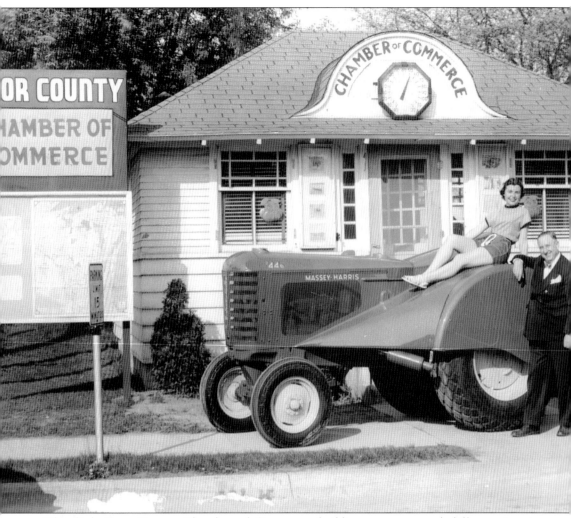

This little Door County Chamber of Commerce building sat on several different sites in downtown Sturgeon Bay. It ended up serving as the secretary's office at the Door County Fairgrounds. At the time of this photograph, it was next to the museum on Fourth Avenue. The director of the chamber, George Resch, poses with a beautiful girl and a tractor. The Sturgeon Bay Businessmen's Club first organized in 1891 to promote the area and support the fledgling tourist industry. Over the ensuring years, this group reorganized and held its first annual meeting as the Door County Chamber in 1925. A year later, they advertised Door County as "The Vacationland of No Regrets."

Sylvan Lodge was the tourist home operated by museum founder, Harry Dankoler, on Bay Shore Drive. Dankoler, a prolific writer throughout his life, loved and promoted his native Door County with books, letters, and a musical anthem proclaiming it "The Pride of the Badger State."

To reach ye place called "Sylvan Lodge"

When ye reach ye thriving city of Sturgeon Bay ask any person to direct ye to ye highway callled Cedar Street (which is ye principal business street of ye city, and farther on is called ye Bay Shore Road); then go northward three miles, and ye will see ye sign "Sylvan Lodge." Enter ye roadway to ye right and ye will find ye drawbridge down and ye latch-string hanging out.

If ye write address as below:

H. E. Dankoler
Route 1
Sturgeon Bay
Wisconsin

ARTHUR BALL
DAVID M. BALL
D. S. CRANDALL
HELEN REINECKER
HARRY E. DANKOLER
A. C. TEMPLETON
ROBERT TEMPLETON
JOHN P. HANSON
FRED. L. WATTERS
HARRY WARNER
CHAS. L. DAVIS
COL. GEO. L. PITTINGER
C. G. DREUTZER
MRS. Y. V. DREUTZER

SYLVAN LODGE

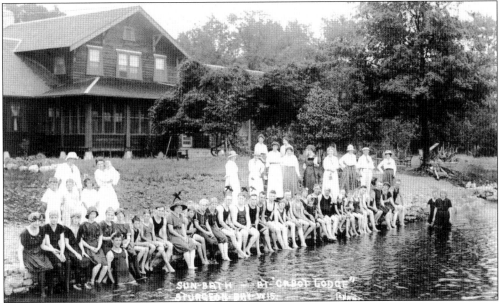

Sun bathers gather at Cabot Lodge on Sawyer Harbor at the mouth of Sturgeon Bay. J. T. Wright built the first summer hotel on this site in 1879 and called it Idlewild, a name by which the area is still known today.

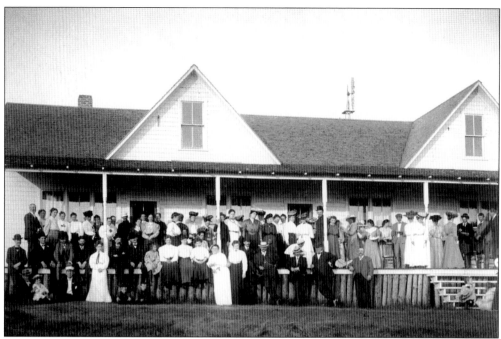

These are views from The Cove Resort. The Cove was built in 1901 by Myron Lawrence from the remains of an old rooming house for canal workers. In addition to accommodations for 200 people in a hotel and cottages, it featured a dance hall, a swimming pool, and areas for boating and fishing. In the early days, there were no decent roads to the resort. Tourists arrived by steamer at the dock in Sturgeon Bay and then took a launch to The Cove. In later years, Myron's son, Dudley, and his wife, Olivia, ran the resort until the night of their daughter's wedding in 1933, when a fire broke out and the dance hall burned to the ground. Cove Road was named after this resort.

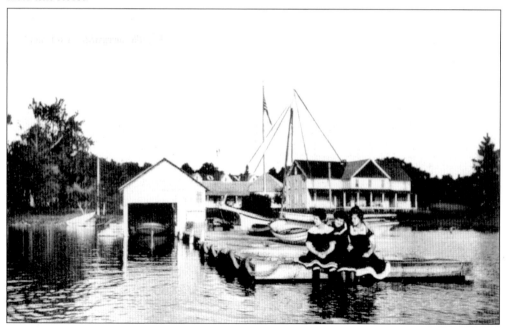

Seven

WORKING WATERFRONT

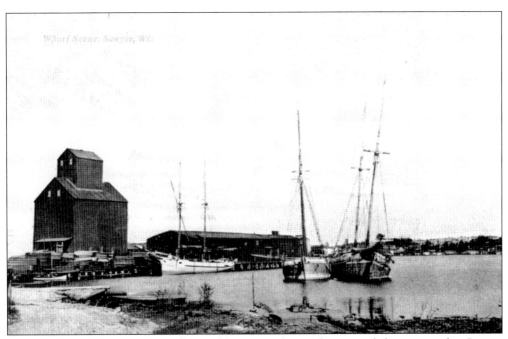

This postcard shows a wharf scene on the west side, in the area of the present-day Sawyer Park. Sturgeon Bay's early waterfront became a busy port, with docks for shipping wood, ice, and stone. Sailing schooners, steamboats, tugs, barges, and fish boats have all been familiar accompaniments to life along the bay. However, as the city grew, shipbuilding and repair yards began to dominate the waterfront. At no time was this truer than during World War II, when the shipyards expanded into maximum production for the war effort. The city strained under pressure to meet the needs of thousands of new workers.

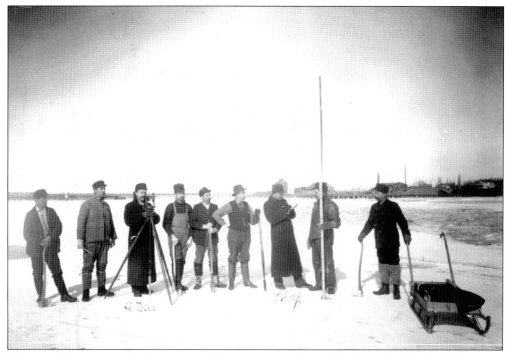

This sounding gang with their axes and measuring stick are checking the depth of the water in Sturgeon Bay during the winter of 1897. From left to right are unidentified, Capt. Ernest Carrington, Adam Dier, Alphonse Gattie, Lester Cheeseman, Capt. Dave Ramage, Bert Thorpe, Charles Vandresek, and Albert Birmingham.

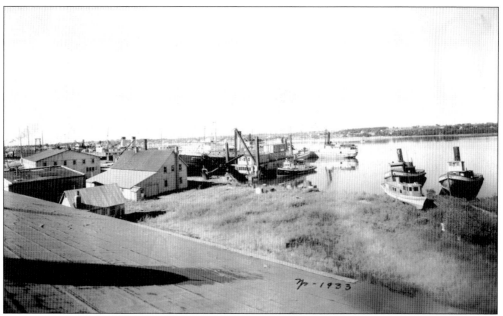

In 1898, August Rieboldt and Joseph Wolter moved their shipbuilding operation in Sheboygan to Sturgeon Bay. They repaired all types of wooden ships, employing as many as 200 men. They also built dry docks. (Photograph courtesy of the Door County Maritime Museum.)

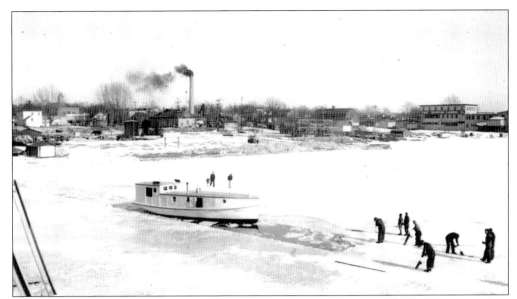

These workers are sawing a path in the ice for a new fishing boat built by Sturgeon Bay Boat Works. They are trying to get the boat to the channel, which was kept open by the car ferries. Visible in the background is the Sturgeon Bay Light Plant, which provided steam heat to the downtown buildings. (Photograph courtesy of Mike and Barb Chisholm.)

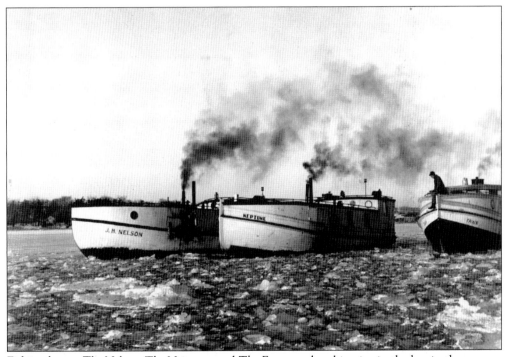

Fishing boats, *The Nelson*, *The Neptune*, and *The Fawn* are breaking ice in the bay in the process of delivering to fish houses in Sturgeon Bay. In the winter, the boats normally docked at the canal, where they had easy access to the ice-free Lake Michigan. (Original photography by W. C. Schroeder.)

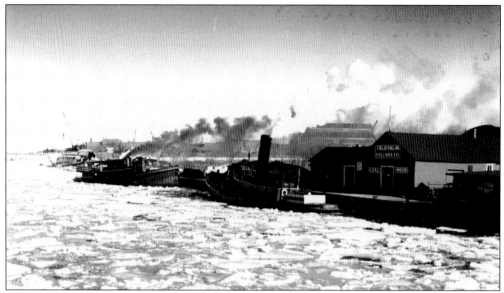

These tugs are docked at the Fidler-Skilling Company, taking on coal to fuel their steam engines. Fidler-Skilling, located on the east side at the foot of Kentucky Street, supplied coke, wood, stoker coal, and fuel oil for commercial and home use. (Original photography by W. C. Schroeder.)

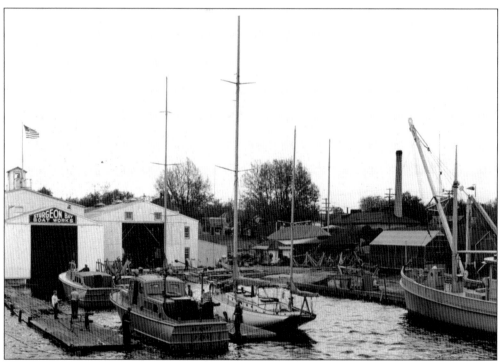

All of the shipyards were working around the clock during World War II to fulfill military contracts. Sturgeon Bay Boatworks, owned by Hans Johnson and his son Palmer, built over 40 air-sea rescue boats, as seen on the left, for the U.S. Army. In 1956, this yard changed hands and was renamed Palmer Johnson Boats Incorporated. (Photograph courtesy of the Door County Maritime Museum.)

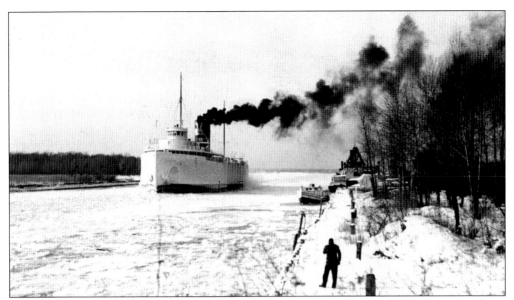

The car ferry *Ann Arbor No. 5* passes through the Sturgeon Bay ship canal. The ferry must have encountered an ice storm that turned its black painted hull completely white. It would stoke up its coal-fired engines and blow black soot into the city air, much to the chagrin of some local officials. (Original photography by W. C. Schroeder.)

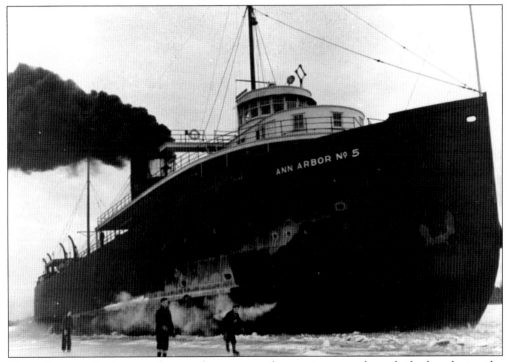

These boys are skating too close to the same car ferry as it passes through the bay during the winter. From left to right are an unidentified boy, Chuck Ferguson, and Roger Schroeder. The ice was not often suitable for such good skating. The boys took advantage of the situation. (Original photography by W. C. Schroeder.)

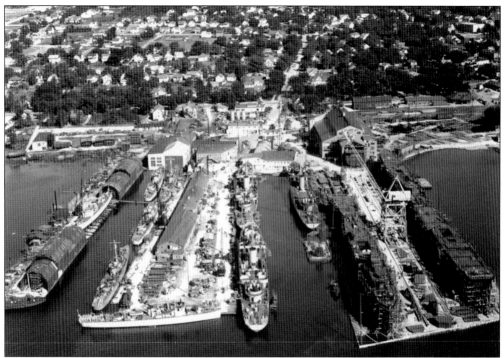

An aerial view shows Smith Shipbuilding at the height of World War II. The 15 ships under construction are sub chasers for the U.S. Navy and anti-submarine Corvettes for Canada. In 1943, the yard hit a peak of one completed ship per week. They hired women as well as men and set up assembly line production, training each person for only one specific job. (Original photography by W. C. Schroeder.)

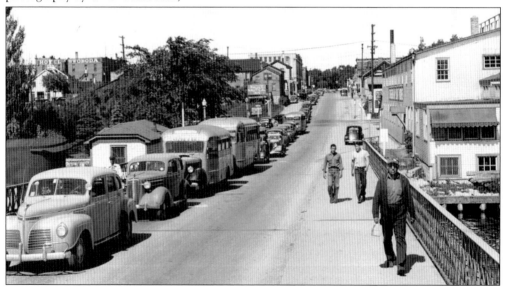

A long line of cars waits to cross the downtown bridge at quitting time. With the yards employing as many as 6,700 workers during the peak of construction in 1944, the huge influx of people taxed the entire city infrastructure, including traffic, schools, and housing. (Original photography by W. C. Schroeder.)

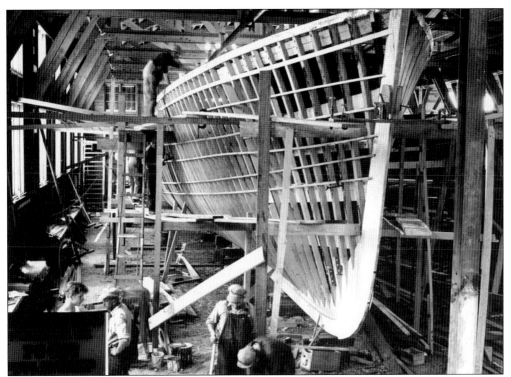

The skeleton of a 110-foot submarine chaser is in progress at Peterson Boatworks during World War II. Peterson built wooden personnel boats, submarine chasers, mine sweepers, and patrol boats. The hulls were built indoors, to preserve the wood, and then finished outdoors. (Original photography by W. C. Schroeder.)

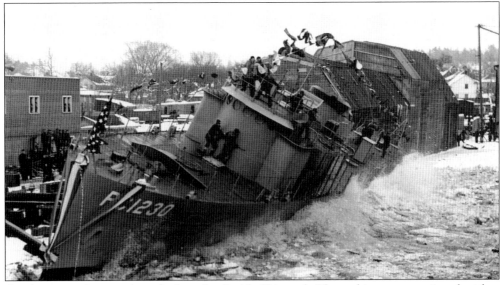

A submarine chaser is launched at the Smith Shipyard. These ships were equipped with a three-inch forward gun, depth charges, and various anti-aircraft weapons. On side launches, a number of men would hang on tight and "ride the boat in" in order to operate the lines after it became water borne. (Original photography by W. C. Schroeder.)

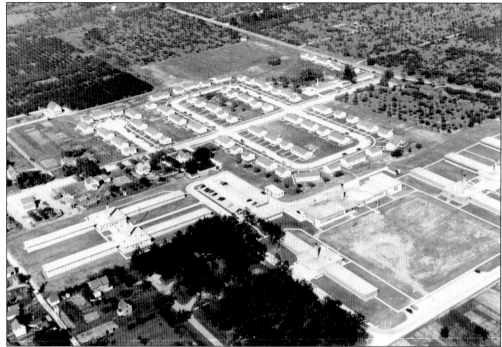

Defense homes were built on the north end of Sturgeon Bay with Delaware Street bisecting the center of the housing development. North Eighth Avenue is the road running along the top right corner. Adjacent to the large playing field was the recreation hall where dances were held. (Original photography by W. C. Schroeder.)

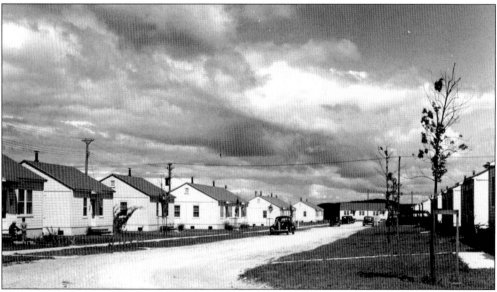

As hundreds of shipyard workers flocked to Sturgeon Bay, the local housing market was saturated. Locals were encouraged to rent out rooms in their homes. Some workers were lucky to get into the government built defense homes. Many of these homes were torn down after the war, but some remain to this day, a proud reminder of Sturgeon Bay's contribution to the war effort. (Original photography by W. C. Schroeder.)

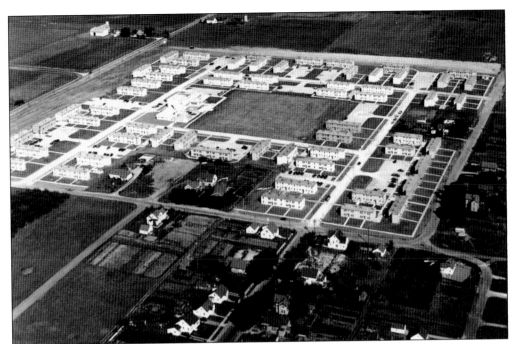

Another aerial view shows the Sunrise Apartments that were also built to alleviate the housing shortage in Sturgeon Bay during the war. These apartments were located in the area bordered by Twelfth Avenue, Michigan Street, Fifteenth Avenue, and Rhode Island Street. Sturgeon Bay School's athletic complex, Memorial Field, now occupies that area. (Original photography by W. C. Schroeder.)

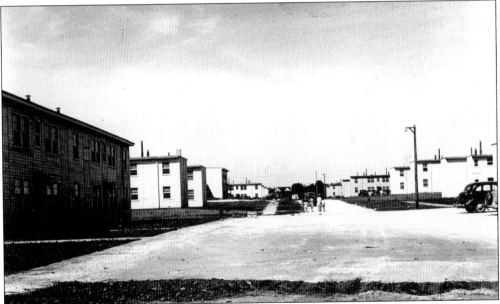

The Sunrise Apartments were assembled quickly. The poor quality of construction and lack of insulation led them to be known as the "Chicken Coops." After the war, they were entirely removed. Some of them were disassembled and moved to the University of Wisconsin-Superior campus to be used for student housing. (Original photography by W. C. Schroeder.)

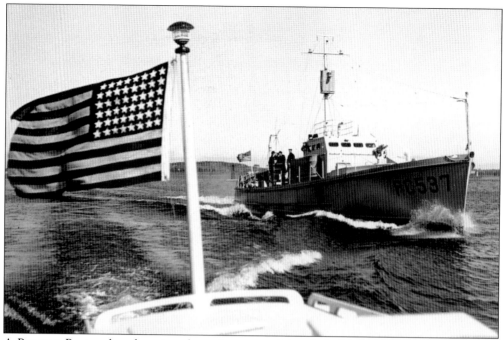

A Peterson Boatworks submarine chaser is on sea trial in Lake Michigan. During World War II, there were a total of 258 ships constructed at the four local shipyards for the navy, army, and foreign buyers. (Original photography by W. C. Schroeder.)

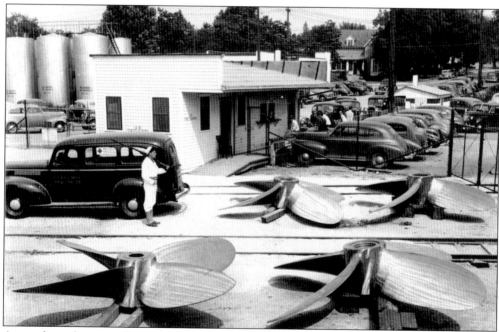

A guard watches over the gate at the Smith Shipyard where bronze propellers were unloaded ready for use with the anti-submarine Corvettes. Members of the U.S. Coast Guard protected the shipyards during the war. The guards also patrolled on a catwalk on the top of the plate shop overlooking the yard. (Original photography by W. C. Schroeder.)

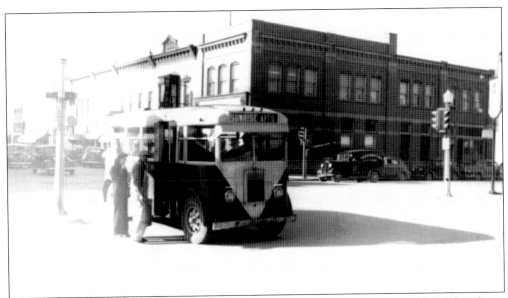

Gordon Weber and Frank Butts started the Sturgeon Bay Transit Company in 1943. Their buses were in demand because of auto shortages, gas rationing, and the many wartime workers and their families in Sturgeon Bay. They ran the line, with three buses, until 1953. Here passengers board a small bus at the transit location at Third Avenue and Michigan Street.

Local officials pose in front of a parade float promoting donations to the war effort. World War I veteran and local judge Grover Stapleton is in the center of the first row. On the home front, citizens did their part with victory gardens, scrap drives, rationing, and placement of an air raid siren on city hall, which is still used today. (Original photography by W. C. Schroeder.)

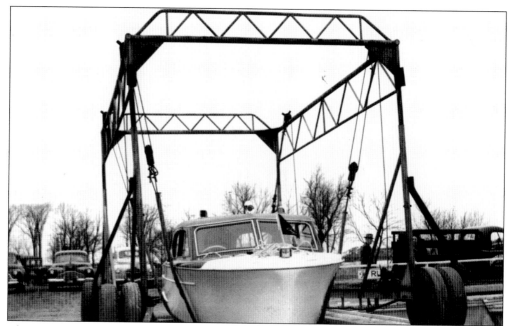

This prototype of a Marine Travelift was invented by marina owner George "Butch" Baudhuin in Sturgeon Bay in 1946. The device backs over the boat slip, straddling the yacht. Slings are lowered under the boat and an electric lift picks it up. The invention, still manufactured in Sturgeon Bay, has gained popularity with boat handlers throughout the world. (Original photography by Herb Reynolds.)

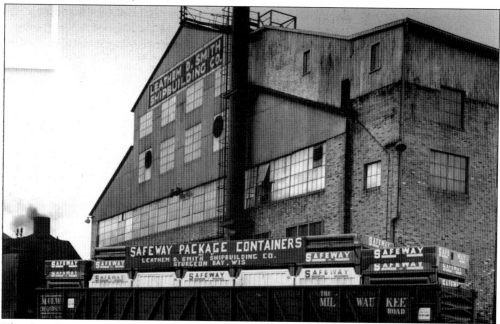

The first shipping containers, the Safeway Containers, were designed and built by Leathem Smith. This revolutionized the shipping industry, allowing manufacturers to load freight at the plant into a container that could be shipped by rail, ship, or truck, eliminating much of the manual labor. (Original photography by W. C. Schroeder.)

Eight

ORCHARDS

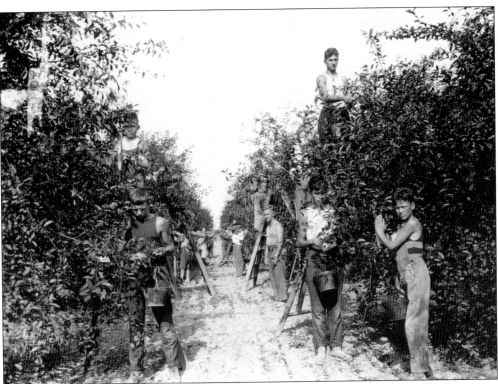

A Swiss immigrant farmer, Joseph Zettel, began planting apple trees north of Sturgeon Bay in 1862. By the end of the 19th century, he had been awarded many prizes for his endeavors. His success piqued the interest of E. S. Goff, a professor of horticulture at the University of Wisconsin, and A. L. Hatch, a prominent orchard grower from Richland County. After the two studied the peninsula's suitable climate and growing conditions, they believed they found the perfect fruit—cherries! They invested in cherry orchards and persuaded others to consider the fruit's production. Soon growers large and small planted cherry trees. Sturgeon Bay became a center for growing, packing, and marketing its now-famous sour cherries.

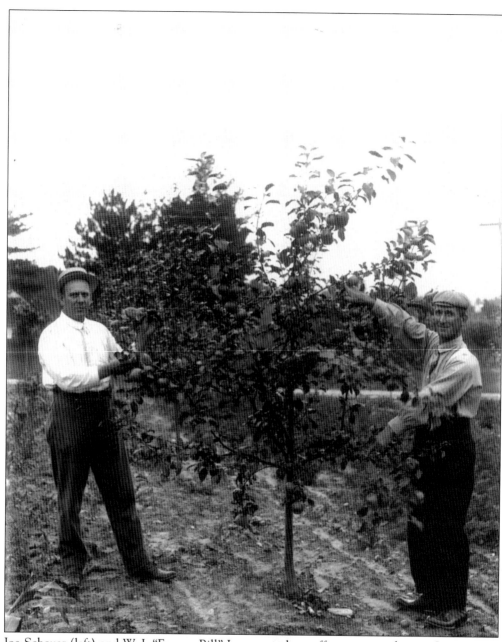

Joe Schauer (left) and W. I. "Farmer Bill" Lawrence show off a young apple tree. Lawrence, a pioneer in fruit production, started planting cherries within the city in 1896. His farm house still remains standing at the top of Egg Harbor Road. Orchard growers like Lawrence were convinced to try fruit production by the scientific evidence given to them by Professor Goff and A. L. Hatch. They felt that the limestone-rich soil would meet the nutrient demands of the fruit trees. In addition, the delayed spring with temperatures kept cool by the waters and ice of Lake Michigan and Green Bay would retard the bloom until after the frosts were over. Such conditions would prevent the tender growth from succumbing to the frosts. Many orchard growers found remarkable success by heeding their advice.

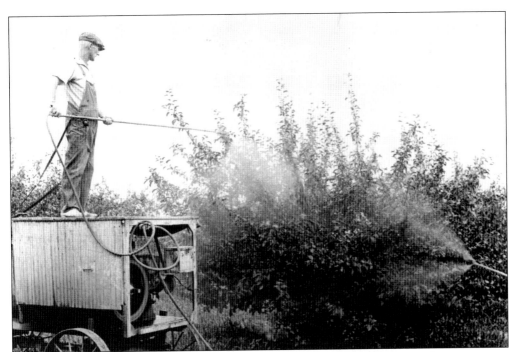

"Farmer Bill" Lawrence is spraying apples in 1921, using one of the first engine driven sprayers, which stopped at every tree. Arsenate of lead was the primary insecticide used at the time. It was an effective insecticide of the past, but has presented both soil and groundwater concerns in today's world due to its continued residue in the historic orchard soils over 80 years later.

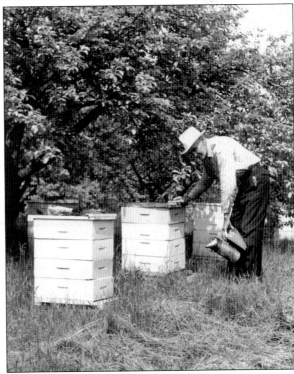

Charles Schroeder, orchard grower and beekeeper, tends to his bee hives. Bees were, and continue to be, a vital component to the success of an orchard, as they assisted with the critical pollination of the blossoms. (Original photography by W. C. Schroeder.)

CHERRY PICKERS WANTED!

FAMILIES and INDIVIDUALS OVER 16 YEARS OF AGE

Door County's Cherry Crop Will Be Ready for Harvesting the Last Week in July!

THE SEASON LASTS ABOUT 5 WEEKS

The Combination of a Good Crop and Good Picking Prices Will Enable You to Make Real Money!

FREE HOUSING

For Information Write

MARTIN ORCHARDS, INC.

Martin Orchard, with nearly 1,100 acres of cherries, boasted of having the "World's Largest Cherry Orchard." Old records show that during the peak of the harvest season Martin Orchard employed as many as 1,300 transient workers. The orchard company provided its workers all the necessities, including housing, blankets, laundry facilities, transportation, a cafeteria, and a first aid dispensary.

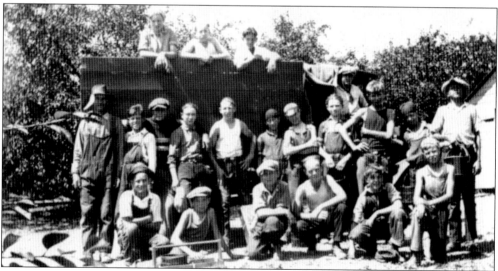

These boys are on a cherry picking crew at "Farmer Bill" Lawrence's orchard. By mid- to late July, all the cherries ripened, demanding a vast pool of inexpensive labor. At first, local families, young men's and women's organizations, and Wisconsin American Indians provided much of the labor. After World War II, Jamaican, African American, and Hispanic migrants formed the core of the labor force in the orchards. (Photograph courtesy of Ralph Herlache.)

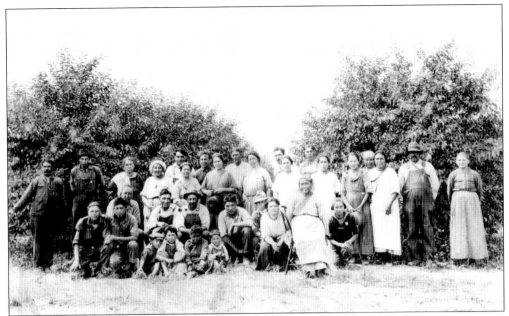

An American Indian picking crew poses in 1928. Orchard owners solicited cherry pickers by making visits to the Stockbridge, Menominee, Oneida, Bad River, Lac Du Flambeau, and other reservations. During the Depression, unemployment created a surplus of pickers, while World War II caused a labor shortage met in part by the use of prisoners of war as pickers.

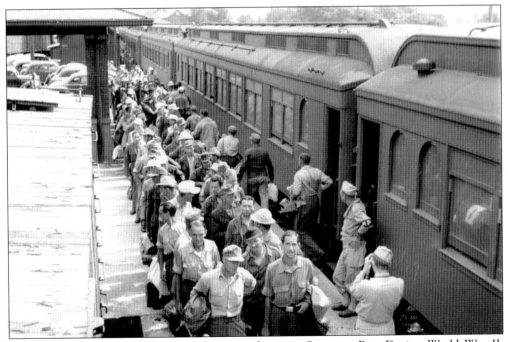

German prisoners of war arrive at the train depot in Sturgeon Bay. During World War II, prisoners of war harvested cherries, apples, and potatoes and performed other needed field work. They were housed at the various orchards, including Martin and Reynolds, and also at the fairgrounds. In 1945, German prisoners of war picked 508,020 pails of cherries in Door County.

Prisoners of war pick the large stones in a field under armed guard. This was a common, but backbreaking, springtime chore in Door County. The county has a thin layer of topsoil covering its limestone bed. Each year, the freeze-thaw cycle helps to carry stones to the surface. The most a farmer could hope for was to clear the stones away for one more growing season. The next spring would bring a whole new "crop."

These prisoners of war are working the soil at Martin Orchard. (Original photography by W. C. Schroeder.)

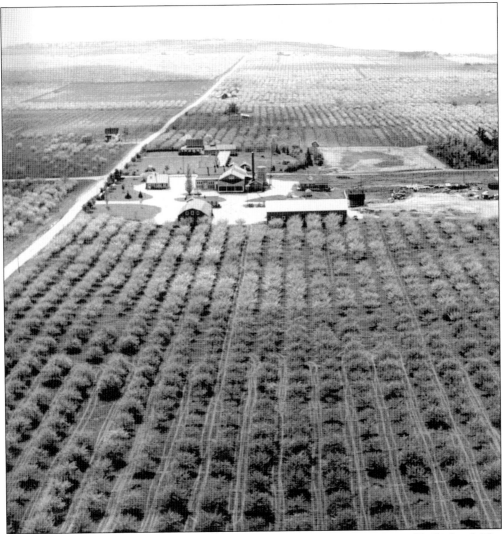

This aerial photograph shows the main buildings and expanse of trees at Reynolds Orchard. The Reynolds family had been involved with sawmills and later a pea cannery in Sturgeon Bay. After witnessing the success of the early cherry growers, by 1911, they planted their first cherries trees. Soon they converted many of their pea fields into orchards. They built a cherry packing plant at the orchard site on Reynolds Road in 1921. By the 1940s, the Reynolds Preserving Company had about 1,000 acres in cherries. They were the largest combination grower and packer of cherries in the world. (Original photography by W. C. Schroeder.)

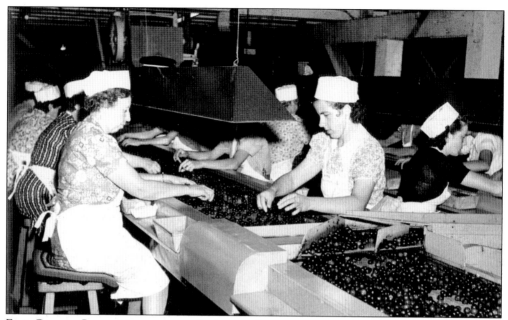

Fruit Growers Cooperative was once the largest cherry processing plant in the world. During the peak season, trucks loaded with cherries waited in line for hours to unload. The line could stretch from the plant, at the Bay, to as far as Fourteenth Avenue. These women are working on the sorting table culling out bruised or damaged cherries. (Original photography by W. C. Schroeder.)

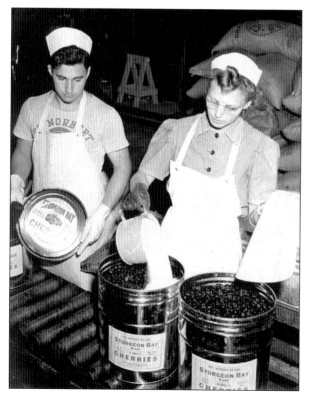

The processing plants hired many seasonal workers. These young people are adding sugar to 30-pound cans of cherries. The lids to these cans were very colorful and advertised the various brands of cherries. They have become popular items to collect for their historic and aesthetic nature. (Original photography by W. C. Schroeder.)

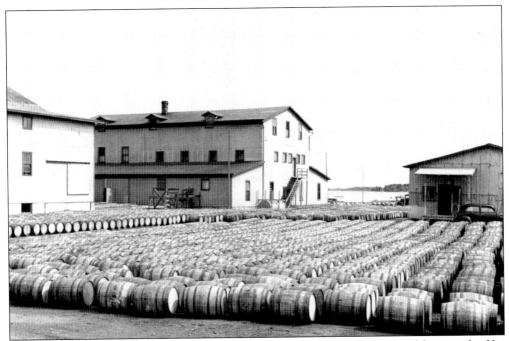

These barrels are half-filled with cherries, floated with water, some powdered lime, and sulfur dioxide. They are curing in the sun as part of the bleaching process necessary to make maraschino cherries. (Original photography by W. C. Schroeder.)

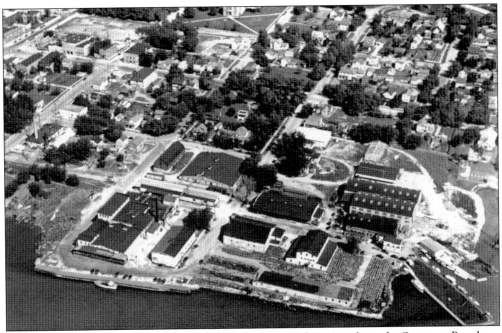

An aerial view of the Fruit Growers Cooperative shows its location along the Sturgeon Bay shore from Oregon Street to the Peterson Shipyard to the south. Originally the site of the Reynolds Lumber Company and later Reynolds Pea Cannery, this cooperative processing plant served hundreds of growers from all over the county. (Original photography by W. C. Schroeder.)

It is the pits! Hans Drexler deals with a mountain of cherry pits at the Fruit Growers Co-op in the 1930s. Over the years, the pits were buried, dumped into the bay, used for pig feed, and packaged as a barbeque additive. A former mayor even tried to make them into a beauty cream! (Original photography by W. C. Schroeder.)

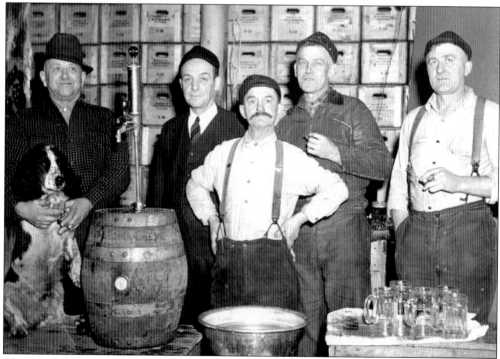

The gang takes a break with a keg of beer at the Fruit Growers Plant. From left to right are Charles "Bow" Augustine, Charles "Chuddy" Soukup, Hans Drexler, "Happy" Propsom, and Allis "Pal" Wills. (Original photography by W. C. Schroeder.)

Earl "Mitch" LaPlant, a local promoter famous for his publicity stunts, outdid himself during the 1939 Cherry Harvest Festival. The most famous event of the festival was the wedding in cherry juice, which took place in a 100-foot tank on Fourth Avenue near the post office. The young couple above, Gerald DeMarb and Francis Blasier, stepped into the 26,000-gallon tank and were married by Judge Henry Graass. Paramount Pictures and Universal Studios newsreels covered the event. LaPlant did not mention that the tank was filled mainly with water and only one barrel of cherry juice. The festival also included parades, band concerts, a Venetian Night boat parade, fireworks, and a new Mercury car that supposedly "ran on cherry juice." After the wedding, Frank Martin conducted swimming races in the tank of "cherry juice." (Original photography by W. C. Schroeder.)

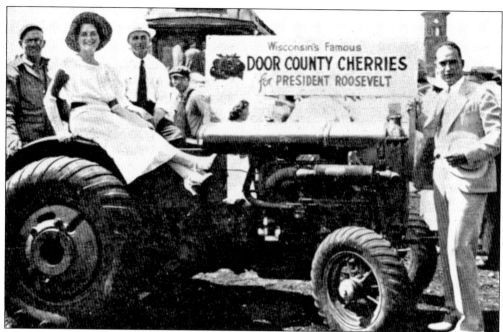

Door County cherries were delivered to President Roosevelt by tractor when he made a visit to Green Bay in August 1935. Claire Acker, Door County's representative to the National Cherry Pie Baking Contest, is posed on the tractor. Karl Reynolds, who promoted the stunt, is on the right.

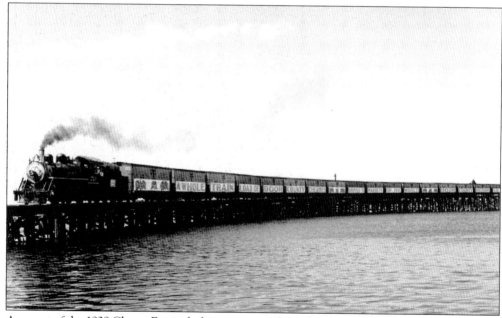

As a part of the 1939 Cherry Festival, this train was adorned with a sign reading: "A Whole Train Load of Door County Cherries Shipped to Markets of the World . . . Door County, Wisconsin's Air Conditioned Playground." Mitch LaPlant, a local promoter who conceived of the "world's largest sign," neglected to mention that there was only one case of cherries on board. (Original photography by W. C. Schroeder.)